Engagement and Access

Innovative Approaches for Museums

About the Series

The *Innovative Approaches for Museums* series offers case studies, written by scholars and practitioners from museums, galleries, and other institutions, that showcase the original, transformative, and sometimes wholly re-invented methods, techniques, systems, theories, and actions that demonstrate innovative work being done in the museum and cultural sector throughout the world. The authors come from a variety of institutions—in size, type, budget, audience, mission, and collection scope. Each volume offers ideas and support to those working in museums while serving as a resource and primer, as much as inspiration, for students and the museum staff and faculty training future professionals who will further develop future innovative approaches.

About the Series Editor

Juilee Decker is an associate professor of Museum Studies at Rochester Institute of Technology (RIT) where she teaches courses focusing on museums and technology so as to bring theory and praxis together in the classroom environment. She has worked as a public art consultant and advisor for more than 15 years and has managed several public and private collections of public art. Since 2008, she has served as editor of *Collections: A Journal for Museum and Archives Professionals*, a peer-reviewed journal published by Rowman and Littlefield.

Titles in the Series

Engagement and Access

Innovative Approaches for Museums

Edited by Juilee Decker

ROWMAN & LITTLEFIELD
Lanham • Boulder • New York • London

Published by Rowman & Littlefield
A wholly owned subsidiary of The Rowman & Littlefield Publishing Group, Inc.
4501 Forbes Boulevard, Suite 200, Lanham, Maryland 20706
www.rowman.com

Unit A, Whitacre Mews, 26-34 Stannary Street, London SE11 4AB

British Library Cataloguing in Publication Information Available

Library of Congress Cataloging-in-Publication Data

Engagement and access : innovative approaches for museums / Juilee Decker.
 pages cm. — (Innovative approaches for museums)
 Includes bibliographical references and index.
 ISBN 978-1-4422-3875-6 (pbk. : alk. paper) — ISBN 978-1-4422-3876-3
(electronic) 1. Museums and community. 2. Museums—Technological
innovations. 3. Museum techniques. 4. Museums—Educational aspects. I.
Decker, Juilee, editor.
 AM7.E54 2015
 069—dc23

 2015009773

Printed in the United States of America

Contents

The volumes in this series are grouped under the following themes: technology and digital initiatives; engagement and access; collections care and stewardship, and fundraising and strategic planning. While each volume has a particular focus, the chapters in each volume rarely address the framing theme of that volume alone. Instead, the reach of the content often dapples in other aspects of that institution's operations. Such intersection and overlap speak to the integrative nature of museum work,[6] as museums function optimally when their areas of operation are not constrained to silos but, rather, when collaboration becomes the driver. An example of this "optimization for innovation," as I like to think of it, is the pioneering work done by the team at the Cleveland Museum of Art in their efforts to bring the museum into conversation with its audiences in multiple, meaningful ways and, ultimately, to become more visitor-centered. Their collaboration yielded Gallery One, an innovative space that fuses art, technology, and interpretation. This space in the museum has become a destination for visitors interested in learning more about art through a variety of hands-on interactives, including the forty-foot microtile, multitouch Collection Wall. Not content merely to implant digital technology and interactives in the gallery, this museum's refocusing on the visitor—as a recasting of the triangulation between the museum, its collections, and its viewers—required changes beyond those in the physical space of Gallery One, such as clearer pathways through the galleries and other new amenities that enmesh the onsite visitor with an entirely new experience-based, interactive visit. Such optimization for innovation required a team of collaborators, who are cited prominently on the museum's website, which notes that this project and the broader initiatives associated therein represent "a true and equal collaboration among the curatorial, information management and technology services, education and interpretation, and design departments at the Cleveland Museum of Art."[7] The chapter addressing this project appears in the volume on technology and digital initiatives, although the case study speaks to each of the other foci of the other three volumes in this series. Just as this project's design, implementation, and maintenance required the collaboration of a number of museum staff from many departments, so too may the case study, and all others in this series, find a home among many departments in your museum.

ABOUT THESE CASE STUDIES

The case studies in this volume address how museums forge two-way communication and engaged participation through the use of community curation, social media, collaboration, and inquiry-based learning.

Such approaches demonstrate how museums serve as thriving, central gathering places in communities that are positioned to offer meaningful, inclusive, creative, and educational experiences.

The examples of engagement and access in this volume are paradigmatic of a shift in thinking. Each of these case studies advocates for *doing* and *listening*. That is to say, these institutions understand the importance of meeting the needs of audiences. And, in the twenty-first century, those audiences are onsite as well as online. While these case studies represent only a handful of initiatives and engaging experiences thriving in museums today, they help us to see engagement and access in terms of virtual collections, the crowd (as in crowdsourcing, crowdfunding, and crowdcrafting), and the onsite experience.

Virtual collections may be limited or expansive, depending upon the purpose and need of both the institution and its audiences. Online collections may take a variety of forms from an online database of collections tied to a museum website or a blog-style narrative to more visual formats such as a Flickr page dedicated to collections items or an app. The range of possibilities is matched by the range of tools available to museums seeking to bring their collections to the fingertips of visitors who have visited their museum as well as those who have not. In the following paragraphs, I will share examples of online collections and tools that might help you to get information about and images of your collections treasures online. (As virtual collections are reliant upon technology, readers will wish to consult several case studies in *Technology and Digital Initiatives: Innovative Approaches for Museums* that address online collections and digitization projects.)

In September 2014, the Metropolitan Museum of Art unveiled its first-ever app to great fanfare (envision a launch party in the Egyptian galleries with the Temple of Dendur aflood with oversaturated lights), though every organization need not create its own splashy app from the ground up. Devoid of bells and whistles, but still providing an additional level of connection to collections, audio tours offer an economical option. A free platform is available through CultureSpots, which offers a user-friendly platform for creating audio tours in a free cloud-based subscription (and additional services including tech support, at a premium). Launched in October 2014, CultureSpots provides barrier-free access to collections that is slim and trim, with attention only to audio, rather than video and multiple points of engagement through media.[8] Maintained in the cloud, the hosting infrastructure is not a burden for the museum or gallery interested in developing the tours. The tours may be created in any number of ways (for instance, by using software such as CultureSpots Voice Recorder, available on the App Store), which allows museums to play around with the technology a bit before initiating a free, "basic plan" that will provide

ten active audios with downloadable QR codes and multilingual access. When comfortable with the technology and maintenance, museums can move to a high-end subscription that allows for ten times as many tours as well as comprehensive support.

In late 2014, Google announced the release of a new technology platform to enable museums to take advantage of Google technology, including StreetView, and YouTube with the aim of using the app at home or in the museum—all the while sharing collections with friends on social networks. The first round of apps was produced in conjunction with eleven institutions.[9] This Open Gallery platform enables registered users—individuals and museums—to upload images, videos, and audios to create online exhibitions. Put simply, Google Open Gallery has supplied highly sophisticated tools for museums to develop virtual collections.[10]

So if you are thinking of making a foray into audio tours or online collections, CultureSpots and Google's Open Gallery are entry points that will not drastically impact your budget but will afford you the opportunity to connect your collections with visitors through myriad means.

Collections, once online, can become a hub of engagement. They can engage audiences inside and outside of the museum through the wisdom of the crowd. To explain, the Center for the Future of Museums aptly forecast the power of harnessing the crowd (crowdsourcing) in the 2012 TrendsWatch. Following up with a report in 2014, Elizabeth Merritt commented on instances and potentialities outside of museums that elicit the dark side of peer sharing.[11] Crowdsourcing is often seen as a way of getting other people to do one's work for free, but in cultural institutions, the notion of unpaid work is welcome. It's a tradition. It's also, keenly, a form of public participation.[12]

Crowdsourcing is a platform for engagement and participation that may take any (or all) of three forms. The first is *initiating* new content in the form of creating a wholly new item (work of art, photograph, story, or other material) that becomes a resource for others to use. The second type of crowdsourcing involves *reworking collections* and mediating content, which might take the shape of transcribing documents. The third is *interacting with existing content* (such as selecting works for an exhibition), tagging images as favorites, or otherwise repositioning existing content through selection.

Museums may strive to utilize one, two, or three areas of tapping into the wisdom of the crowd—as demonstrated by several case studies in this volume. It is important to note, however, that crowdsourcing has been a part of the museum experience for years as the notions of initiating, reworking, and interacting with the collections speak to museum tenets of social interaction, connection, and engagement. Two examples, one involving technology and another that need not, serve to illustrate the

ways in which museums tap the crowd. The low-tech example is the tra-
ditional comment card or other evaluation instrument. When museums
invite responses from their visitors, they are tapping into the wisdom of
the crowd—albeit on a smaller scale than the vastness of the Internet's
users. But the organizing principle of the crowdsourcing is the same: a
query is posed and responses are submitted. Many museums have taken
to a Post-it note variation that enables visitors to answer and share their
ideas to questions that museums pose. For instance, William Hennessey
and Anne Corso, Chrysler Museum of Art, and Marisa J. Pascucci, Boca
Raton Museum of Art, describe their empowering use of a blank wall,
Post-its, and pencils and pens to empower visitors to share their thoughts
and to contribute to the exhibition experience through social interaction,
connection, and engagement.

A second example of tapping the crowd speaks to the use of social
media as a tool of social interaction, connection, and engagement. In con-
trast to the ubiquitous request not to photograph *anything* in a museum,
institutions seem to be embracing their collections being mediated by
visitors by overturning previous mandates against photography and, by
extension, embracing the innate desire of visitors to document.[13] Chances
are you have witnessed one of these encounters or authorized one your-
self: the museum selfie, a photograph that one has taken of oneself with a
digital camera or smartphone that is often shared via social media. While
certainly there is, still, the propensity for museum visitors to ask another
patron to take a staged photograph of one's self (or a group), the trend
is toward the selfie. Selfies have a kind of quaintness that speaks to the
engaged practice of museums in a way that a formalized portrait cannot.
By taking the photo, you authorize that you were there and—like my
students amidst the treasures from Sutton Hoo—you share that experi-
ence with those near and far. You connect with your followers instantly
on social media and you share this moment of engagement and access
with them. But that is not to say that the gallery should revert to a Wild
West, no-holds-barred shoot-out among visitors to fight for space in front
of Sue, the *Tyrannosaurus rex* at the Field Museum of Natural History in
Chicago or some other collections item.

Inside and outside of the museum, questions have arisen as to whether
selfies and portable devices belong in museums at all. Coming out in favor
of them, Marc Check, associate vice president, information and interactive
technology at the Museum of Science (Boston), recently commented, "Peo-
ple don't necessarily come to the museum for the content. . . . Our studies
are showing us that people are coming for a social experience."[14] Initiated
in 2014, #MuseumSelfie Day is a one-day, crowdsourced phenomenon that
aims to promote awareness of collections of museums worldwide. Orga-
nized by Mar Dixon, a London-based advocate for culture and museums,

the event floods Twitter with visualizations of audience engagement from a range of tweeters, including museum directors. For instance, Gerard Vaughan posed in front of the title wall of the James Turrell retrospective at the National Gallery of Australia in Canberra.[15] At the Royal Saskatchewan Museum, director Harold Bryant took part as well, and the poster even added some humor to his post: "Our Director Dr. Harold Bryant and Scotty the T. rex together in a #MuseumSelfie They both have great teeth!"[16] The second time the event was held, January 21, 2015, yielded amazing statistics with more than 27,000 tweets (posts), 169,600,000-plus impressions (the number of times users saw the tweet on Twitter), 13,000-plus contributors, and 57,600,000-plus reach (how far the tweets traveled).[17] Organizer Dixon, who has not worked for a museum but advocates for engagement, commented, "Today is about being happy, having a good time and getting involved. . . . Even if one person goes to a museum today who never goes, just to be a part of this hashtag experience, isn't that great?"[18] Imagine the possibilities of bringing a work—or many—from your collection into the hands of more than 57 million tweeters!

Despite these astonishing figures that represent virtual engagement with collections and the people who visit them even if only on this day, there are some who oppose the phenomenon of the museum selfie, citing the disruption to the experience of others that such posing and posting enlist.[19] Moreover, the focus of the image-making in the museum selfie becomes the viewer, not the collections item. Museum professionals, even as they have embraced the #MuseumSelfie, demonstrate myriad uses of social media for a variety of other purposes. In fact, cues as to how to engage audiences with social media may be gleaned from several of the contributions in this volume, and others in this series, in fact, touch on social media as part-and-parcel of museum engagement and (possibly) the museum experience in the twenty-first century. See particularly Margot Note's discussion on World Monuments Fund's experimentation and success with Instagram and the case study by Smithsonian staffers Charles Chen, Jennifer L. Lindsay, Siobhan Starrs, and Barbara W. Stauffer, which discusses the link between online and onsite engagement at the National Museum of Natural History. Each of these examinations realizes the capacity of social media to provide a platform for engagement onsite and online.

What does the import of social media and its online and onsite intermingling mean for museums more broadly? In the case of the Smithsonian, social media and crowdsourcing have meant an endorsement of their roots as well as recognition of the authority of the visitor who contributes to the call of the museum. Recently a term was coined for the individuals who contribute to such endeavors (as crowdsourcing refers to the method and crowdsourced refers to the outcome—neither term applies to the

participants). In the case of the Smithsonian transcribers, the "crowd" are called "volunpeers"—to recognize their role as both volunteers and peers collaborating on a large-scale project.[20] In discussing this project, Meghan Ferriter, project coordinator for the Smithsonian Transcription Center,[21] has commented on the ways in which the transcription center has grown into a community of transcribers working in consort with Smithsonian staff. The partnership occurs within the transcription center through the use of the "Notes" field for each collections item to be transcribed.[22] In addition, the Smithsonian responds to queries posted through social media, which has also provided an outlet for discoveries under the hashtag #volunpeer.

But this seemingly disruptive behavior is not new to the institution. Effie Kapsalis, Smithsonian's head of web, new media, and outreach, connects current projects and initiatives to the institution's earliest activities—the gathering of meteorological data in the 1840s by Joseph Henry, the first secretary of the Smithsonian.[23] Kapsalis explains, "Crowdsourcing is really what we do at the Smithsonian. It's embedded in our DNA. Since our founding, our mission has been to increase and diffuse knowledge. So we're increasing by taking in knowledge from our curators, our scientists, but also the public."[24] Kapsalis acknowledges the role of technology in these endeavors: "We've been doing crowdsourcing for a long time, but today it's really changed in scale because of technology, so today we have over thirty projects actively going on with thousands of volunteers contributing."[25]

Like the Smithsonian, the British Museum has launched a large-scale crowdsourcing project asking viewers to transcribe a handwritten catalog.[26] The site describes projects as "applications" and clearly connects the work of volunteers to that of the British Museum staff by noting the importance of the task. "This application will help the British Museum's curator of the Bronze Age collections, Neil Wilkin, to make available a huge card catalog of British prehistoric metal artefacts discovered in the 19th and 20th century. . . . Metal finds are not only crucial forms of evidence for dating Britain's prehistoric past, but also tell us a great deal about prehistoric society and economy."[27] Another application is photomasking as a first step in rendering a 3-D model. MicroPasts asks contributors to draw polygons around the artifacts so as to outline the item and ignore the background.

MicroPasts also incorporates the other side of the crowd—crowdfunding—in order to draw support for community-based archaeological and historical projects. In the MicroPasts platform, funds only change hands when the minimum threshold is met within a stated deadline.[28] This program of conducting, designing, and funding research pools the wisdom, will, and purse of the crowd and, in exchange, offers up data to the public.

The key is that this platform embraces the notion of the citizen archeologist who can work collaboratively with researchers, historical societies, and other members of the public to create research data and to design and fund new projects as well. (As crowdfunding relates to fundraising, readers will wish to consult the volume *Fundraising and Strategic Planning: Innovative Approaches for Museums*, which addresses successful case studies in this area.)

In addition to initiating new content (in the form of uploading images) and reworking collections (as in the transcription examples above), crowdsourcing refers to instances of interacting with existing content. Recently, the National Maritime Museum in Greenwich, England, took advantage of Flickr's visuality and commenting features to engage with audience members who performed the role of collaborators. Their project *Curate the Collection* resulted in a physical exhibit that went on view in the fall of 2012 at Greenwich.[29] Bringing the ideas from the collaboration and personalized learning trail forward, the Museum's Compass Lounge continues to imprint the collections on the visitor. The Compass Lounge and Compass Card "open up the Museum's objects and archives and demonstrate the connections between diverse histories and people."[30] Visitors are given a Compass Card that is their passport to expanded content. Card in hand, visitors look for compass point signals within the galleries and insert the card into the kiosks to "collect" the story about the item. The card can be read at the Compass kiosk in the lounge. A personalized collection is sent to the visitor as an e-book. Beyond the gallery visit, participants can sign up for a username to create their own collections (if not gathered onsite) and to tag items from the collection. In both of these instances, the collections are at the forefront of the online and onsite experience, and that experience is mediated through individualized learning trails.

Crowdsourcing isn't solely for the large organization or those with grand budgets: there is room for everyone and organizations of every type and size to shepherd a project like this. Though many examples exist of crowdsourcing platforms, a free, open-source alternative is Crowdcrafting, which was created in 2011 at a hackathon in Cape Town, South Africa.[31] Though seemingly disconnected from the work of museums now, this kind of open-source platform asks volunteers for online assistance in performing tasks that require human cognition, such as transcription, geocoding, and image classification.[32]

Thus, whether uploading an image (perhaps a selfie) to Flickr or a museum site or app, transcribing field books in support of the collections of the Smithsonian, or selecting works for an exhibition, online and onsite visitors have the authority and the ability to become contributors to the

work of the museum. Moving the focus from the institution to the institution and its audiences as a community, audiences in the twenty-first century have become empowered to contribute. They are authorized both *by* and *through* engagement and access.

Beyond the capacity of the crowd to contribute and (potentially) to fund the museum's endeavors, the audience at large has become an important focus of the museum and voice within it. In this regard, museum professionals and museum studies as a field of inquiry have benefited tremendously from the work of John Falk and Lynn D. Dierking, who began more than two decades ago to acknowledge the audience at a time when visitors were considered, if at all, the third wheel to the object and the (authority of the) institution. Continued efforts by scholars and practitioners in the field have paid tribute to the changing place of the visitor in the museum.

In addition to the framing of online collections, crowdsourcing, and, on occasion, the import of technology to some aspect of an engaging experience, how else are visitors given greater or, even, more focused but intentional access to collections? How are visitors curating their own experiences onsite?

Several museums have begun thinking about their audiences in new ways. For instance, the Denver Art Museum (DAM) has proposed that *style*, rather than age, become a means of looking at audiences. While we tend to think of audiences by *age group* (young adult, emerging professionals, seniors), we can gain much by orienting the crafting of an experience around collections that pays heed to broader *interests* (mystery lovers, foodies). The interest and experience becomes the driver rather than a defined age group. For instance, DAM developed their "Demo and Do" program with young adults in mind, but found that families and older individuals liked the balance of time learning and doing. The propensity toward making is the driver, rather than the mere age of the experience seeker. Another example that stresses interest over age is the *Murder at the Museum* program begun in November 2014 at the World Treasures Museum in Wichita, Kansas. The program is a riff on the murder mystery party where attendees are given an identity to assume upon arriving at the museum (in costume, of course). The evening combines mystery with food and drink as well as collections. Building upon the theme and context, the interactive mystery experience is held at the museum and situated in the 1920s, thereby affording the museum staff to select an appropriate item from their arms collection for the curator of collections, Steven King, to display and handle during the event.[33] In this volume, Jan Freedman of Plymouth City Museum and Art Gallery, and Janet Sinclair, Stansted Park, examine site-based opportunities that speak to the importance of place and its connection to heritage. Further case studies by J.

Patrick Kociolek, University of Colorado, and Sarah Lampen, Stephanie Parrish, and Eric Steen, Portland Art Museum, highlight sensory experiences as drivers. Kociolek discusses efforts to attract students and faculty to the university's Museum of Natural History through the reframing of a portion of the space as an exhibition and programming area called the BioLounge, complete with free coffee and tea! In Portland, museum staff collaborated with an area artist (Eric Steen) to create *Art and Beer*, an event first held in 2014 that celebrates craft brewing in conjunction with the genre painting in the museum's collection. Both projects—one ongoing and the other an annual event—are a siren call to lure the thirsty to the gallery.

Thinking about their audiences in new ways also means *redefining* an audience of a museum as *audiences* (plural). To this end, a key area of development has been the capacity of museums to serve underserved audiences through their collections. From 1991 to 1999, the Wallace Foundation aimed at propelling art museums, in particular, into a new era of service by challenging them to find ways to attract and serve diverse audiences. The resulting reports from the foundation demonstrate changes in practices, identity, and ethos of museums while authorizing a challenge for museums to follow in the footsteps of the twenty-nine museums funded over those years.[34] Ideas from these publications include the establishment of teen councils and business partnerships, the embrace of the authenticity of visitors, and outreach to neighbors of museums—that is, the residents who live near the facility itself. Each of these suggestions, if carried out, like the work of engagement as well, requires careful research, planning, and coordination among museum staff and the constituencies served.[35]

This volume comprises evidence of successful access initiatives. For instance, Ashley Hosler details the Walters Art Museum's programming that aims to reach and engage children with autism spectrum disorders. Her case study demonstrates the careful planning, implementation, assessment, and evaluation that has been undertaken to provide modified programming attuned to user needs while being fully aware of the atypical demands that passing through the threshold of a museum may put on an individual and his or her family. Alison Zeidman, Greater Philadelphia Cultural Alliance, explains a wildly successful program implemented in 2013 that seeks to empower Philadelphia's youth by offering free access to museums and other cultural institutions and by promoting cultural institutions as destinations for leisure activities.

Engagement and Access analyzes how and why engagement and access can, and should, be mediated online and onsite. Such activities, done well, will broaden audiences by increasing their size, deepen them by enriching the experiences that the participants and visitors have, and

diversify them. Contributing to the discussion, a recent publication offers advice for all museums on creating meaningful experiences for audiences—and, by extension, the staff of the museum. *Advancing Engagement* looks at ways of reaching out to audiences through the collections. Some suggestions are to position the museum as the center of learning; to set up a poets-in-residence program; and to craft opportunities for repeated engagement over the course of a student's career. Each of these, and the many other experiences described in the volume, elucidates the ways in which the museum offers learning potential, experiences, and opportunities far beyond subject-based frameworks of education.[36]

Likewise, the case studies in *Engagement and Access: Innovative Approaches for Museums* offer suggestions for museums by calling attention to the importance of museum audiences onsite and online. The chapters demonstrate the ways in which museums are using social media and crowdsourcing (be it the paper-and-pen, Post-it, or online variety). Further, the case studies highlight a variety of focused, onsite experiences that broaden, deepen, and diversify audiences, all the while offering the potential to broaden, deepen, and diversify the experience of the museum visitor—a symbiotic relationship made palpable on that winter day with my students and the volunteer at the "hands-on" desk in Room 41 of the British Museum.

NOTES

1. The items are currently in Room 2 of the *Collecting the World* installation at the British Museum.

2. The 1938 discovery at the village of Sutton Hoo lay neatly and compactly in several vitrines. From a mounded plot of land came a cavernous space that held the remains of a ship, coins, and other decorative metalwork. Among these were a leather purse with a jeweled lid and forty-one pieces of metal: thirty-seven gold coins, three blanks (semifinished pieces of metal intending to be struck into coins), and two ingots (lumps of metal). The coins were struck in France between the years 575 and 620 CE. Excavation that occurred in three phases over the twentieth century yielded a sword and sheath, helmet, scepter, bowls, and other objects on view here and at the Sutton Hoo heritage site in East Anglia.

3. Morris Hargreaves McIntyre, "Touching History: An Evaluation of the Hands On Desks at the British Museum," Manchester, 2008, 3.

4. Morris Hargreaves McIntyre, "Touching History: An Evaluation of the Hands On Desks at the British Museum," Manchester, 2008, 7.

5. Morris Hargreaves McIntyre, "Touching History: An Evaluation of the Hands On Desks at the British Museum," Manchester, 2008, 9.

6. For instance, technology and digital initiatives require financial support (as does everything!) while informing strategic planning which, in turn, may aim to enhance engagement, access, collections care, and stewardship, among other areas

of concentration and action. (Every title of the books in this series is included in the previous sentence!)

7. Cleveland Museum of Art, "Collaborators," www.clevelandart.org/gallery-one/collaborators. The statement continues, "The development process was guided by CMA's chief curator and deputy director, Griff Mann—an atypical and noteworthy approach among museums in the design of interactive technology spaces. Museum educators were instrumental in curating the space and its related experiences, and IMTS staff worked closely with internal and external partners on both concept and interactive design. This collaborative organizational structure is groundbreaking, not just within the museum community, but within user-interface design in general. It elevated each department's contribution, resulting in an unparalleled interactive experience, with technology and software that has never been used before in any venue, content interpreted in fun and approachable ways, and unprecedented design of an interactive gallery space that integrates technology into an art gallery setting." The site also recognizes their partnership with Local Projects, who, under the direction of Jake Barton, designed all of the media and collaborated with the CMA team on concept design development.

8. See CultureSpots, "About," culturespots.com/about/.

9. See Google Cultural Institute, www.google.com/culturalinstitute/home.

10. See Google, www.google.com/opengallery/.

11. Elizabeth Merritt, "Thursday Update: When Does the Crowd Become a Mob?" Center for the Future of Museums, August 14, 2014, futureofmuseums.blogspot.com/2014/08/thursday-update-when-does-crowd-become.html.

12. This differs from crowdfunding, which asks for individuals to contribute to support a project, as we will encounter in the *Fundraising and Strategic Planning* volume in this series.

13. The broader phenomenon of visitors documenting the museum experience, not necessarily the selfie, is the subject of a forthcoming publication that heralds the visitor as creator, *Museums and Visitor Photography*. The book examines what kinds of photographs are produced, how they are created, and why. See the notice for the publication in "Museums and Visitor Photography: How Visitors Use Photography," January 2015, *MuseumsETC Magazine*, museumsetc.com/blogs/magazine/16667260-museums-and-visitor-photography-how-visitors-use-photography. The publication will be edited by Theopisti Stylianou-Lambert.

14. See George LeVines, "Do Selfies and Smartphones Belong in Museums? Many Curators Say Yes," betaboston.com/news/2015/01/21/do-selfies-and-smartphones-belong-in-museums-many-curators-say-yes/.

15. The caption reads, "Our director Gerard Vaughan striking a pose for #MuseumSelfie Day! #NGATurrell," January 21, 2015, www.facebook.com/JamesTurrellRetrospective/photos/a.750608358309384.1073741828.747271798643040/796919933678226/.

16. See the image and caption at the Twitter feed for the Royal Saskatchewan Museum @royalsaskmuseum: twitter.com/royalsaskmuseum/status/558012490789834752.

17. Mar Dixon, "#MuseumSelfie Day 2015—Press, Stats and More!" January 21, 2015, www.mardixon.com/wordpress/2015/01/museumselfie-day-2015-press-stats-and-more/.

18. Jareen Imam, "Selfies Turn Museums into Playgrounds for a Day," January 21, 2015, www.cnn.com/2015/01/21/living/feat-museum-selfie-irpt/.

19. In 2014, Chloe Schama, writing for *New Republic*, asked people to ignore this inaugural endeavor and to give up this behavior for the sake of everyone in an art museum. See Chloe Schama, "Stop Taking Selfies in Front of Works of Art!" January 22, 2014, www.newrepublic.com/article/116310/stop-taking-selfies-front-works-art. As the statistics reveal, her appeal fell on deaf ears.

20. See "#volunpeer" on Twitter: twitter.com/hashtag/volunpeer as introduced by @TranscribeSI. The Smithsonian Transcription Center works with digital volunteers to transcribe the collections to make "our treasures more accessible."

21. Smithsonian, Smithsonian Digital Volunteers: Transcription Center, transcription.si.edu/.

22. Meghan Ferriter, "Growing to a Community of Volunpeers: Communication and Discovery," July 8, 2014, siarchives.si.edu/blog/growing-community-volunpeers-communication-discovery.

23. Elena Bruno, "Smithsonian Crowdsourcing Since 1849!" *The Bigger Picture: Exploring Archives and Smithsonian History*, April 14, 2011, siarchives.si.edu/blog/smithsonian-crowdsourcing-1849.

24. Smithsonian. "SI-Q: How Can You Help Make History with the Smithsonian," October 3, 2014, www.youtube/EXU-JQ_TemA.

25. Smithsonian. "SI-Q: How Can You Help Make History with the Smithsonian," October 3, 2014, www.youtube/EXU-JQ_TemA.

26. MicroPasts: Crowd-sourcing, crowdsourced.micropasts.org/.

27. British Museum, "British Museum Bronze Age Index Drawer A19: Devizes Museum," www.crowdsourced.micropasts.org/app/devizes. An example of a 3-D render is www.micropasts.org/3D/. The site also includes a forum with queries and troubleshooting.

28. Andy Bevan, Chiara Bonacchi, Adi Keinan-Schoonbaert, and Dan Pett, "Introduction to Crowd-funding," April 30, 2014, crowdfunded.micropasts.org/how-it-works.

29. For views of the museum's Flickr stream, see www.flickr.com/photos/nationalmaritimemuseum/. The exhibition page is here: "Curate the Collection," March 13, 2013, curatethecollection.wordpress.com/. The images selected were on view at the Compass Lounge. The projects were directed by Bronwen Colquhoun, a Ph.D. student at Newcastle University, and the museum's digital participation officer, Jane Findlay. See Flickr blog, "Curate the Commons," May 23, 2012, blog.flickr.net/2012/05/23/curate-the-commons/.

30. Royal Museums Greenwich, "The Compass Lounge," www.rmg.co.uk/whats-on/exhibitions/compass-lounge.

31. Crowdcrafting, "About," crowdcrafting.org/about.

32. Employing PyBossa software, Crowdcrafting allows users to download the software, follow the tutorial, and create a new project.

33. Joe Stumpe, "Crack the Case at the Museum of World Treasures," *Wichita Eagle*, November 6, 2014, www.kansas.com/entertainment/article3603723.html.

34. See "Opening the Door to the Entire Community: How Museums Are Using Permanent Collections to Engage Audiences" (1998); The Wallace Foundation, "Engaging the Entire Community: A New Role for Permanent Collections" (1999);

and "Service to People: Challenges and Rewards: How Museums Can Become More Visitor-Centered" (2000).

35. In 2014, the Wallace Foundation released a study that identifies and explains nine actions that arts organizations can take to engage audiences. See Bob Harlow, *The Road to Results: Effective Practices for Building Arts Audiences*, New York: Bob Harlow Research and Consulting, LLC. In 2014, the foundation also released Pamela Mendels, *Thriving Arts Organizations, Thriving Arts: What We Know About Building Audiences for the Arts and What We Still Have to Learn*. Both reports are available from the Wallace Foundation website. See www.wallacefoundation. org. In October 2014, the foundation also announced a multiyear initiative keyed to audiences and engagement entitled "Building Audiences for Sustainability." While each of these documents and the initiative are focused on the arts rather than museums, they can offer support and ideas for museum professionals who wish to increase access and expand, deepen, and otherwise broaden engagement. See the Wallace Foundation, press release, "The Wallace Foundation Announces Six-Year, $40-Million Initiative to Support—and Learn From—About 25 Performing Arts Organizations That Engage New Audiences," October 1, 2014, www.wallacefoundation.org/view-latest-news/PressRelease/Pages/The-Wallace-Foundation-Announces-Six-Year,-$40-Million-Initiative-to-Support-Arts-Organizations. aspx.

36. Though aimed at academic museums, the publication offers sound advice for all museums seeking to further engage and to broaden their reach. Edited by Stefanie S. Jandl and Mark S. Gold, *Advancing Engagement: A Handbook for Academic Museums*, Volume 3, Boston: MuseumsETC Press, 2014.

ONE

Listening to Our Audiences

William Hennessey and Anne Corso,
Chrysler Museum of Art

We in the art museum world have always been very good at talking to ourselves. We have devised a special language that most outsiders find incomprehensible. Confident in our expertise and judgment, we often believe that we know what is best for our audiences. This is not a very attractive picture and, after a good hard look in the mirror, we at the Chrysler Museum have committed ourselves to changing it. We have rewritten our mission statement to focus not just on our collection but on how we use it; our new focus is on both art *and* people. We have reorganized our staff to support this mission and have begun the process of shifting our institutional culture so that we can become better listeners—understanding and responding to the needs of the audiences we exist to serve. In the pages that follow we outline the steps we have taken toward this goal.

PLANNING

First, allow us to introduce you to the Chrysler Museum—a midsize art museum in Norfolk, Virginia. Founded in 1933, the museum is home to a collection of more than thirty thousand objects covering five thousand years of human history. We present an active schedule of exhibitions, programs, and events for visitors of all ages and backgrounds. With an annual budget of $8 million, we employ just over one hundred people. Our mission is to "enrich and transform lives by bringing art and people together." We take this charge very seriously and believe that our continuing success depends on our ability to make the Chrysler a place that makes a positive difference in people's lives. This means building a responsive relationship with our audiences. It means making the museum

a genuinely relaxed, welcoming, and accessible place. It means having a real conversation with our visitors, talking with, not at them.

From Haughty to Hospitable

Those of us who work in museums every day generally find them familiar and comfortable places, but our visitors have told us they find museums intimidating. In the past they've described our building as formal, wondered if they would be welcome, and worried that nothing inside would be relevant to their lives. When they did muster the nerve to enter, the first person they encountered was a uniformed guard. Like most security professionals, this individual had been trained to size up every visitor as a potential threat. No wonder visitors felt uncomfortable and had the sense they were being followed or regarded with suspicion. They worried that they were going to be chastised for getting too close, for not following some rule, even for looking too hard. Under such conditions it is no surprise that many visitors found it hard to relax enough to really engage with the works of art that were the reason for their visit.

IMPLEMENTATION

Sobered by these insights, we resolved to turn this dynamic upside down. We began by creating a new senior management position focused solely on improving the experience of our visitors. Then we removed our traditional security officers from the galleries (they still work behind the scenes) and replaced them with gallery hosts. Our hosts are informally dressed, and they open our front door for every visitor. In the galleries, hosts engage visitors in conversation or offer to take their picture; they smile and make eye contact with everyone, creating an environment where everyone—from grade-schooler to scholar—feels welcome. If they are asked a question and don't know the answer, they call colleagues for help. All of us—curators, conservators, educators, even the director—are ready to respond. No one is ever too busy to stop and assist a visitor.

It is worth noting that all gallery hosts also carry radios, are trained in CPR and first aid, have been drilled in emergency and safety procedures, and have learned techniques for effectively dealing with problems of all kinds. Their security function operates in the background, as their first job is to make visitors truly welcome, to enable them to relax and enjoy the collection.

The results of this shift have been dramatic. Visitors say that they now feel like honored guests. In surveys, comment cards, and letters they de-

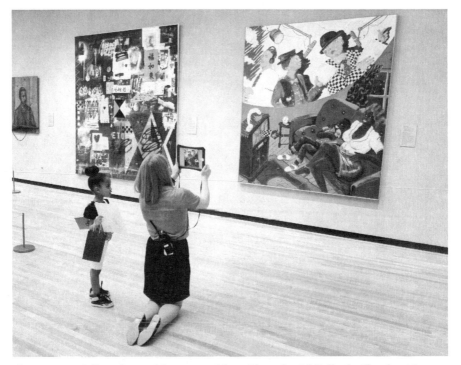

Figure 1.1. Gallery host with young visitor. Photo by Ed Pollard, Chrysler Museum photographer.

scribe their visits in glowing terms, highlighting both the collection *and* the genuine welcome offered by the staff.

What Does Art Sound Like?

A young student stands in front of a vivid canvas depicting more than thirty musicians in the midst of a performance. A gallery host approaches the girl and casually engages her in conversation: "What do you think their song sounds like?" After a little discussion, the host holds up her iPad in front of the painting and says, "We think it might have sounded like this." As the tablet recognizes the image, an orchestra bursts into song—a lively rendition of the music most likely played by the painted band. This project, *Listening to American Art*, pairs contextualizing audio with works found throughout the museum, and it is one piece of the Chrysler's new interpretative model.

In the spirit of breaking down barriers, the museum sought to develop a new model for interpreting the exhibitions and works of art as part of

our 2014 renovation. The model had four distinct components. First, we reorganized the education department. Rather than having educators solely dedicated to certain segments of the audience, we created positions designed to focus specifically on interpretation, educational technology and new media, and audience engagement.

Second, we rewrote every label and text panel for the reinstallation according to new standards: we abandoned art historical jargon and used clear and concise writing to direct the visitor to look actively at the object. We also sought to answer visitors' specific questions that we had collected through conversations over the years.

Third, we reconsidered how we choose what goes on display and how we display it. Although we installed the galleries chronologically, we intentionally included artwork and multimedia installations that break the chronological flow. For example, a cast glass dress by contemporary artist Karen LaMonte echoes the drapery of a reclining female form atop an ancient Roman sarcophagus. Such "activations" often surprise visitors and prompt rich conversations.

Finally, we explored the best way to use technology in the galleries. Focusing carefully on reinforcing our mission of bringing art and people together, we created programs like *Listening to American Art*. What makes this initiative successful is not simply the information that the technology provides or the multidisciplinary approach to conveying it, but rather that the technology serves as a tool, one that visitors already use in their everyday lives, to engage in a conversation.

"I Hate Tomatoes"

Art museum visitors read plenty of words on gallery walls. But what happens when the words are written by other visitors and not by museum professionals? At the Chrysler, on public view they'll find widely diverse phrases such as: "Powerful. I've struggled with addiction for 11 years," and "I didn't like the glass hamburger because it had a tomato. I hate tomatoes." At first, these two statements seem to be worlds apart, but they both have an important effect—they prompt conversations. Rather than being told what to think or see, visitors begin expressing their own insights, and they start to communicate with one another.

Some institutional history will paint a clearer picture. In 2012, the Chrysler hosted *30 Americans*, an exhibition of contemporary African American art that grappled with issues of race, sexuality, and violence, often in a deliberately provocative manner. For instance, an installation by Gary Simmons featured a ring of child-sized stools topped by white pointed hoods that encircled a noose hung from the ceiling. While committed to presenting the artists' works, the museum also wanted to be sensitive to

the visitors' emotions by encouraging their own expression. The museum tried a very low-tech experiment, but one whose immediacy had powerful results: we installed a series of response stations next to the art, giving people a chance to voice their opinions in direct response to the work. It required only blank wall space, Post-its, and pencils. Visitors did the rest. Although staff initially worried that visitors might harm a painting with a Post-it or write an inflammatory comment, the rewards were evident quickly. The walls became covered from floor to ceiling with sticky notes full of comments. Visitors voiced their own opinions, revealing aspects of the works no one on staff had ever considered. They also responded to other visitors' comments, creating conversations and thought-provoking debates. Every day, the staff found powerful expressions in the gallery. One notable comment read, "Makes me want to scream *I'm sorry* for what has happened."

Although *30 Americans* was a temporary exhibition, it reinforced that visitors want to actively participate in a dialogue with the museum, its staff, and with each other. More importantly, it prompted an institutional decision that the visitors' voice should always be heard in the museum in a way that is neither moderated by staff vetting and editing nor relegated to a subtly placed comment book. As the museum opened its doors after the largest renovation in its history, we installed large response stations

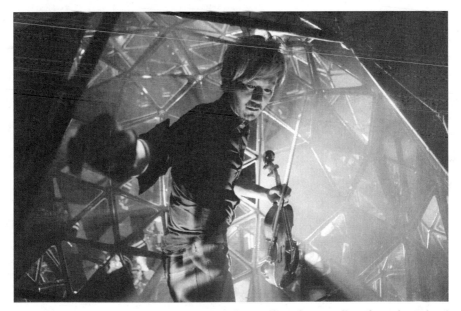

Figure 1.2. Kishi Bashi plays Third Thursday at the Glass Studio. Photo by Echard Wheeler for the Chrysler Museum of Art.

in prominent gallery areas where visitors can write messages and install them on the walls. The responses serve as constant reminders that when you ask visitors what they think, they will delight you, surprise you, and even humble you.

A Simple Question Sparks a Hotshop

It might seem like a great leap of faith for a museum to convert an aging 1960s bank into a seven-thousand-square-foot glass studio. But this impetus was spawned by curious visitors. At least a third of the Chrysler Museum's thirty thousand objects are glass, and for many years the collection was displayed with little interpretive information, under the belief that great works of art speak for themselves. When asked, we learned from our visitors that their most frequent question was, "how were these objects made?" So when the building across the street became available in 2007, museum leadership decided it should be purchased and converted into a state-of-the-art glass studio capable of bringing the single largest part of our collection to life, right in front of our visitors' eyes. But by working closely with artists, we quickly found the studio not only could educate visitors about historical objects, but also could inspire them with new creations and performances, all while developing new audiences. In free daily demonstrations, staff artists complete an entire work in about an hour, sometimes re-creating an object from the collection and other times creating something entirely from their own imaginations. Using a conversational style, the demos encourage visitors to ask questions and chat with our artists about their work and connect to the museum's objects in new ways.

Perhaps the most innovative program at the Glass Studio is its Third Thursday performance art program. This series invites the next generation of museumgoers into an intimate setting. Performing arts such as live music and dance are combined with glassblowing to create an event that can be entertaining, cerebral, experimental, or social. What's more is that this new influx of creativity is not only changing the perception of the museum, but also, by helping to stimulate Norfolk's burgeoning Arts District, is having a concrete impact on the urban economy.

Taking the Museum to the Community

In an effort to bridge the gap between the worlds inside and outside the museum, we reached out to colleagues at the Virginia Arts Festival and the Norfolk city government who were also searching for opportunities to extend arts programming into the streets and parks of our city. Together we launched a series of partnership programs in which we have taken family-friendly, interactive programs to the community.

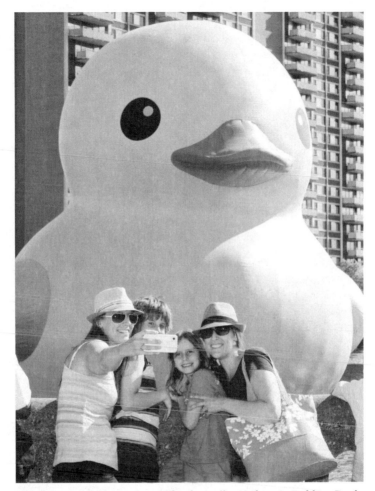

Figure 1.3. Visitors pose with Florentijn Hofman's Rubber Duck. Photo by Ed Pollard, Chrysler Museum of Art Photographer.

During the spring of 2014, we staged our most successful outdoor event when we invited Dutch artist Florentijn Hofman to float his celebrated giant sculpture, *Rubber Duck,* in the Hague Inlet just outside the museum's front door. For ten days, a forty-foot-tall, bright-yellow inflated duck bobbed in the water immediately in front of the museum. While at first there was considerable skepticism about how a replica of a bathtub toy might fit within the museum's mission, *Rubber Duck* became an enormous success on every level. Over 150,000 people, from infants to octogenarians, came to see it. Many families returned multiple times, and countless

photographs were taken and shared—1.6 million people looked at *Rubber Duck* on Facebook. *Rubber Duck* became a regional phenomenon, the topic of constant conversation, and something everyone felt they had to see. And everyone who came smiled. *Rubber Duck* also did something else quite remarkable. It got people talking about the museum. During the *Duck*'s visit, we welcomed over forty thousand visitors—five times our normal attendance for a similar time period. Not only had many of these visitors never been to the Chrysler before, but many had never visited *any* art museum. They discovered, sometimes to their surprise, that museums are pretty rewarding places—places to have fun with friends and family, and also places to learn and think.

RESULTS

At the beginning of our project we set ourselves the goal of better meeting our mission by becoming a more audience-focused institution. We worked hard to shift our attitude toward our patrons, first by becoming better listeners and then by responding to what we heard.

How did we do? In most ways, very well. Our gallery host program, the Glass Studio, and our community partnerships have been successful beyond our most optimistic hopes. Annual attendance, which long averaged about 160,000 is on track to be well over 200,000 this year. Visitor demographics have shifted in a very positive way. The number of our visitors with incomes under $40,000 has risen from 6 percent to 21 percent, non-Caucasians consistently make up 26 percent of our visitors, and 20 percent of our guests now bring their children as against 14 percent in earlier years. Our net promoter score (a measure of the enthusiasm with which our visitors recommend the museum to others) has risen from 72 before the introduction of the gallery host program to a remarkable 95 today, and there has been a real shift in the way the museum is perceived by our peers. We were selected as a case study in the AAM published book *Magnetic: The Art and Science of Engagement,* and our studio and host programs are recognized as national models with Chrysler staff regularly consulted by other institutions.

LESSONS LEARNED

At the same time, our interpretation, technology, and feedback initiatives, while off to a good start, are very much works in progress. Looking back, perhaps the single thing we would have done differently is to allow more

time for staff and volunteers to adjust to a new way of thinking, to get people on board.

DRILLING DOWN: WHAT'S NEXT?

So what's next? How do we continue to build on the progress we have made so far? How do we avoid falling back into bad habits and professional isolation? Not surprisingly, we worry a good deal about the answers to these questions. But we have at least a couple of things that we think will help. At the museum, we all try to remind ourselves (and each other) daily of our mission and values—why we are here. We have put in place a solid strategic plan with clear goals that are ambitious yet attainable and measurable. We stay alert to new ways (both high- and low-tech solutions) to keep the dialogue with our community open and alive. And we will continue to look for and create opportunities for community partnerships as a way of building relationships and connecting with new constituencies. Most of all, we constantly remind ourselves that while we are dedicated to conserving artworks for generations to come, we are devoted to engaging with our visitors. And to bring our art and visitors together, we first need to listen.

TWO

Museum Access for All

Engaging Children with Autism Spectrum Disorders

Ashley Hosler, The Walters Art Museum

The potential for cultural institutions to serve as a community's foundational center is fully realized when the collective populace can access it; social equity, aging populations, and the contextual definition of disability demonstrate the need for universal consideration. Museums employ innovative approaches to reinvigorate their collections. Once activated, objects and artifacts have the ability to connect, inspire, and educate seemingly disparate groups of people. Civically minded institutions welcome a greater number of visitors and, in turn, create mutually beneficial and thriving connections to the community supporting them. This cyclical relationship is all encompassing; this is access.

With a founding commitment to "strengthen and sustain [the] community,"[1] the Walters Art Museum was gifted to the City of Baltimore "for the benefit of the public."[2] The institutional mission to "create a place where people of every background can be touched by art"[3] is woven into all aspects of audience engagement and has inspired educational practices since 1934. As a leader in education for early-childhood, school-age, and multigenerational audiences, the Walters continually assesses the breadth and depth of its programs. In the fall of 2010, the museum recognized families of children with autism as an underserved audience. With a working understanding of developmental domains, diverse learning styles, and the impact of differentiated instruction, the museum collaborated with Embrace International, a nonprofit organization committed to sustaining and enhancing inclusive opportunities for individuals with cognitive and developmental delays. The organizations' shared mission of unlimited access to community resources soon led to the implementation of *Sensory Morning*, an accessible program designed to benefit a significant portion of the mid-Atlantic region.

Through early detection, greater awareness, and broader criteria for diagnosis, the population affected by autism spectrum disorders (ASD) appears to be growing. While the Centers for Disease Control and Prevention (CDC) continues to adjust its estimate, the occurrence of autism is, at the time of this publication, one in sixty-eight.[4] Consider individuals on the spectrum and the families, caregivers, and professionals related to them; consider their spiraling need for services; consider the social and humanitarian obligation that cultural institutions have to provide impactful opportunities for the people who fill them; consider those who long to visit but face participatory obstacles.

PLANNING

Cultural institutions are most successful when visitors feel welcomed and appreciated, seemingly simple human needs to meet. The planning process for sensory morning began by acknowledging threshold fear, a common hesitation to enter a museum based on prior experiences or concern of the unknown. The potential for added stress and grave discomfort faced by families of children with ASD or sensory processing disorders (SPD) is enough to isolate these populations. Many worry about their child's behavioral responses in relation to museum expectations. Neurotypical[5] children socially intuit the rules of a museum environment, self-regulating to walk, whisper, and maintain spatial awareness. Conversely, those on the spectrum need explicit, attainable guidelines and, more importantly, opportunities for success when unable to adjust natural impulses.

In consultation with researchers, therapists, clients, and their families, the Walters Art Museum and Embrace International captured voices of an underserved population and the professionals who advocate for them. Through candid front-end evaluations, the Walters learned of the obstacles faced by families of children with autism. The primary cause of museum avoidance was fear of being ostracized for their child's responses to sensory stimuli. A recent participant of the museum's access programs and mother of a child on the spectrum confirmed that "families with kids who have 'invisible disorders,' like autism or sensory challenges, often stay away from museums and other similar places because the judgment and negativity of other patrons and staff can be exhausting and upsetting." For ASD and SPD audiences, this anxiety severely limits social experiences. As a result, holistic development is compromised, negatively affecting their ability to engage, connect, and relate to others. The weight of these concerns not only inhibits them from visiting, but denies their family an opportunity to experience the museum together.

The Walters and Embrace International asked prospective participants to outline personal needs through formative evaluations. The outcomes developed by its target audience advanced *Sensory Morning* from conception to fruition. Limitations of physical barriers were weighed as heavily as the intangible and perceived barriers. Accepting that some obstacles were out of the realm of modification (namely, physical space), the museum focused on predictable disturbances related to environment. Whenever possible, gallery spaces were adapted to benefit program participants through controlled audio and lighting, child-directed exploration of tactile materials, and use of enlarged visual aids.

Bearing in mind that pleasure is relative and particularly diverse for those along the spectrum, consideration of over- and under-response to sensory stimuli informed lesson development. Large, open rooms; dimly lit galleries; and echo-producing spaces can cause distress or anxiety for some, yet stimulate joy for others. Because preferences vary by individual, the opportunity for choice is fundamental to the success of accessible programming. To combat physical and environmental variables out of the museum's control, educators and occupational therapists conceived Sensory Break Areas—safe spaces designed for those in need of respite. The private, dark, contained space of the museum's auditorium and the public, sky-lit, open area of the Sculpture Court offered reprieve from activities and the opportunity to utilize therapeutic resources intended to stimulate or depress.

During the final stages of planning, the Walters Art Museum and Embrace International finessed program logistics. *Sensory Morning* would begin at 9 a.m., one hour before public opening. Early admission and an established event capacity addressed the concern of overwhelming numbers. Interpretive materials and collection-based resources within the galleries would help to bridge physical and abstract gaps between viewer and object. Designated galleries were to be staffed by trained museum professionals and volunteer therapists with an assortment of educational games, fidgets (handheld objects engineered to intrigue the sensory system while increasing focus and attention), and activities constructed for the enjoyment of a wide range of learners. Touch materials, such as Family Guides and Seek and Finds, would assist visitors in the creative and critical thinking process. Station activities intended to support learning were designed to encourage social interaction and conversation. Space to practice yoga with the guidance of a movement teacher would account for kinesthetic learners while providing opportunities to develop gross motor skills. Above all, the program would confront the most prevalent barrier to access: cost. *Sensory Morning* was designed for families of children whose numerous support services often add to financial strain. Truly

accessible, these events would complement the museum's goal to sustain free admission.

IMPLEMENTATION

Between 2010 and 2014, the Walters hosted eleven *Sensory Morning* events, with frequency growing each year. As a direct result of participant feedback and an exponential growth in attendance, these events are now offered quarterly. The primary objective of *Sensory Morning* is to provide

SENSORY MORNING
SUNDAY, OCTOBER 26, 9–11 A.M.
FREE FAMILY FUN!

Your entire family is cordially invited to a Sensory Morning at the Walters Art Museum.

Walters Art Museum educators and therapists from Kennedy Krieger Institute will be present for the entirety of the event. We are here to help your family have a great time!

Accommodations will be made in consideration of unique sensory needs. Visual resources, tactile activities, sensory breaks, hand fidgets, and opportunities for guidance and structured support will be available throughout the galleries.

Use our *Faces & Feelings Fun Pack* as you explore expressive paintings from the Italian Renaissance!

WE WELCOME
- Kids being kids!
- Children's voices
- Weighted blankets and weighted vests
- Ear plugs and headphones
- Hand fidgets
- Sensory breaks
- Wheelchairs and other mobility devices

SCHEDULE
9–11 a.m. Art activity in a private studio, with adjoining space for quiet time and sensory breaks

9–10 a.m. Self-guided tours and hands-on activities throughout our Renaissance & Baroque Art Galleries

10–11 a.m. Doors open to the public; activities continue

Advance registration required.
E-mail Ashley Hosler at ahosler@thewalters.org, or call 410-547-9000, ext. 325.

THE ART
WALTERS
MUSEUM *WHAT WILL YOU DISCOVER?*
600 N. CHARLES ST. BALTIMORE, MD 410-547-9000 thewalters.org

Figure 2.1. *Sensory Morning* promotional flier distributed to ASD and SPD audience members, clinicians, and professional advocates.

unique, arts-focused opportunities for diverse learners of all ages and abilities while establishing an environment that is welcoming, engaging, and free of judgment. Every program focuses on a distinct collection of objects from antiquity through the nineteenth century. In addition, *Sensory Morning* participants have the opportunity to develop social skills within their community, often resulting in an increased sense of belonging.

Upon check-in, families are welcomed with a complimentary fidget, pre-visit materials specific to the morning, and a brief orientation on the designated spaces and activities. Participants self-guide throughout select galleries, the Family Art Center and adjoining studios, and Sensory Break Areas during the 120 minutes allotted for the event. Informal lessons help guide participants' learning experiences through the free-play necessary for skill acquisition and social development.

The museum's pilot program, held in December 2010, welcomed 37 participants; by March 2013 *Sensory Morning* hosted 98 of 133 registrants, and 101 of 132 the following year. Requiring preregistration allows the Walters to maintain the intimate museum experience desired by many of its visitors with ASD and SPD. The museum strategically overenrolls with the understanding that despite best intentions, many families will experience difficulty making it out their front door. Keeping record of both projected and actual attendance, the education division is equipped to advocate for routine programming, impactful approaches to web-based and print marketing materials, and the value of community outreach. Increased interest in the museum's *Sensory Morning* programs has afforded the development team with tools necessary to sustain access; funding and visibility have multiplied in large part due to cross-divisional support.

RESULTS

In an effort to strengthen and modify programming that better meets the needs of a growing audience, the Walters continually seeks input from the community. There has been overwhelming gratitude from the participants in this program, and families are eager to provide candid feedback. Thus, the Walters has been able to maintain best practices in access, including marketing, branding, and implementation, by collecting measurable data at the conclusion of each *Sensory Morning* event.

Assessment methods were reexamined and modified as educators prepared for the museum's fourth program. The Walters wondered if participants were less inclined to visit during regular hours, and through a combination of qualitative and quantitative evidence, learned that 48 percent of its participants were first-time visitors.

The museum considered the strategies employed by families to overcome threshold fear. Though the audience consistently cited Social Stories and Visual Schedules as preferred pre visit materials, many noted the importance of discussion related to expectation and reward, behavior and consequence. Some incorporated the Walters in daily conversations leading up to their visit, others made use of social and digital media to introduce an unknown space, and many returning families reminded their children of previous experiences.

In an effort to assess the effectiveness of modifications and uniquely designed resources, the museum asked participants to provide feedback on their use of interactive stations, access to the studio, and time spent in Sensory Break Areas. The Walters learned that 89 percent of participants took part in gallery activities. Anecdotal evidence supported an overwhelming appreciation for staff and volunteers: "friendly," "helpful," and "patient in following [child's] lead while [considering] cognitive level and prior knowledge."

Special interests offer an escape for children with ASD. For those who respond favorably to visual stimuli or lose themselves in art history, a visit to the museum can be an opportunity to transport. The benefits associated with open-ended material exploration and self-expression are immeasurable; *Sensory Morning* has enabled 77 percent of participants to take part in a studio art activity.

Calming to some while invigorating to others, the Sensory Break Areas have been utilized by 72 percent of participants. Children "needed space to be [themselves]" and "had lots of energy that needed to be expended before [completing] the art project."

Perhaps of greatest significance, the museum wondered what percentage of families (based on interactions with staff, use of resources and interpretive materials, and comfort within the museum environment) planned to return with or without uniquely designed programs running. One hundred percent of participants answered yes, including the 48 percent who were visiting the Walters for the first time. One adult responded, "I cannot tell you what an event like this means to a family with a special needs child. It was so nice to be someplace where people understood that [our child] has different needs and has different reactions to things. It was great to have so many ways to engage him. And no judgment, no dirty looks from anyone—just lots of acceptance and understanding. We don't always have that when we are out."

Sensory Morning at the Walters affords individuals on the spectrum an opportunity to navigate unfamiliar environments with their families. Exploration of tactile and visual connections to objects enables participants to apply school-acquired skills in a real-life setting. In this way, museums can provide practical opportunities for diverse audiences to develop

relationships with others while exercising social skills in a safe and welcoming space. An early intervention specialist who supports *Sensory Morning* through advocacy and event participation describes the necessity of museum access by explaining that "individuals on the spectrum tend to become 'stuck,' learning a skill in a certain setting and then not perceiving its relevance out of that context. Making sure new social skills are practiced and used far beyond the clinic or school setting is crucial to a social skills training program's success." Museums can provide endless opportunity for healing and belonging. Moreover, they have an obligation to provide absolute access to the greater community.

DRILLING DOWN: WHAT'S NEXT?

Specifically developed for ASD and SPD audiences, *Sensory Morning* demonstrates recognition of, and respect for, diverse learning styles through modified programming. Though indisputably strengthening the community, these programs are not without challenges. Exclusive and offered less frequently than the Walters and the intended audience would consider ideal, *Sensory Morning* events demonstrate an inherent contradiction to both the concept of universal design and the institution's commitment to providing "access for all" without differentiation.

The Walters is committed to museum-wide access beyond designated program hours and strives to create a permanently inclusive and accommodating space beyond events. With support from the Center for Autism and Related Disorders (CARD) at the world-renowned Kennedy Krieger Institute, all museum staff and volunteers are scheduled to receive accessibility training. These forthcoming professional development opportunities for front-line staff will better equip the team with skills necessary to best serve the public, connecting with families in meaningful ways. Together, the knowledge and empathy gained will contribute to the growing support for individuals on the spectrum in and out of the museum setting.

With plans to organize an Autism Advisory Committee comprised of therapeutic professionals, parents, and institutional colleagues, the Walters is working toward inclusive community consideration by developing adapted museum guides, digital resources for use at home and within the galleries, and expanded off-site program offerings. The museum aims to empower its target audience and ultimately bolster the number of independent visits.

At the heart of every access-driven programmatic decision the Walters Art Museum makes is the awareness that children, regardless of cognitive and developmental ability, learn through exposure. Museums have the

capacity to be more than a collection of artifacts; imagine the endless possibilities for personal and communal growth if every institution created experiences driven by this empowering realization: special interests in the arts and humanities can become invaluable motivators for overcoming challenges, delays, and deficits. This is museum potential. This is access.

NOTES

1. "The Walters Art Museum," *Mission Statement of the Walters Art Museum*, adopted by the board of trustees, January 9, 2001, thewalters.org/about/mission. aspx.

2. "The Walters Art Museum," *Last Will and Testament of Henry Walters*, included in the Walters Art Gallery Act of Incorporation, Ordinances of Mayor and City Council of Baltimore, By-laws, etc. Baltimore, MD, 1934.

3. "The Walters Art Museum," *Mission Statement of the Walters Art Museum*, adopted by the board of trustees, January 9, 2001, thewalters.org/about/mission. aspx.

4. Centers for Disease Control and Prevention, "Data and Statistics," March 24, 2014, www.cdc.gov/ncbddd/autism/data.html.

5. Neurotypical refers to healthy cognitive development and related social and communication skills that contrast with character traits of ASD.

RESOURCES

Center for Autism and Related Disorders (CARD) at Kennedy Krieger Institute: www.kennedykrieger.org/patient-care/patient-care-centers/center-autism-and-related-disorders.
Centers for Disease Control (CDC) and Prevention: www.cdc.gov/.
National Center for Learning Disabilities: www.ncld.org/.
National Institutes of Health: www.nih.gov/.
Sensory Processing Disorder Foundation: www.spdfoundation.net/about-sensory-processing-disorder.html.
Very Special Arts, The Kennedy Center: www.kennedy-center.org/education/vsa/.

THREE

STAMP

An Innovative New Program to Engage Teen Audiences

Alison Zeidman, Greater Philadelphia Cultural Alliance

In 2013, the Greater Philadelphia Cultural Alliance officially launched STAMP (Students at Museums in Philly): the Virginia and Harvey Kimmel Family Teen Program. STAMP is an innovative new program to make arts and culture more accessible to Philadelphia teens ages fourteen to nineteen. The mission is to increase teens' access to the incredible arts and culture Philadelphia has to offer, as a means to discovering their own identities and including culture in their menu of leisure-time options. Our goal is to nurture the next generation of arts participants by instilling a lifelong appreciation for arts and culture and its role in self-expression, education, and civic engagement. The key components of the program are the STAMP Pass, which is a free pass open to any Philadelphia teen and valid for year-round free admission to a selection of the city's top museums and attractions, as well as special events throughout the year; the STAMP website, where teens can sign up for a pass, get information on the museums, and discover other opportunities to get involved with arts and culture organizations (such as classes, workshops, and job opportunities); and the STAMP Teen Council, whose members' responsibilities include promoting the program to their peers and regularly giving input on how to make arts and culture more appealing to teens.

PLANNING

The Greater Philadelphia Cultural Alliance is a membership and service organization working on behalf of the arts and culture sector to support the growth of arts organizations and their audiences. The alliance offers many services, and one of the work areas for which we are best known is our innovative research on the health of the sector and the relationships

35

Figure 3.1. STAMP Teen Council members Sharon Shania and Jordan Deal visiting the African American Museum in Philadelphia. Photo Credit: Karim Olaechea.

between the region's residents and its cultural organizations. In compiling our 2010 *Research Into Action* report, we discovered that Philadelphia teens were an audience greatly underserved by the city's arts and cultural organizations. Furthermore, census data and our own research on the demographics of Philadelphia high schools showed that a majority of teens were African American or Latino, and over one-third came from economically disadvantaged areas. We saw the potential for a teen program to be a tool for diversifying audiences not only by age, but also by race and economic status. One of the priorities in the Cultural Alliance's Strategic Plan is to "strengthen the sector by helping cultural organizations to . . . diversify their audiences and build engaging, high-quality experiences," so launching a dedicated program to connect member organizations with teen audiences fell well within our strategic priorities.

We wanted to create a way for teens to think of cultural institutions as places they could visit in their free time. The intent was for our teen program to differ from other student-focused arts programs that concentrate on arts education by instead encouraging teens' independent engagement with arts and culture. Lowering the barrier for entry to museums seemed like a natural first step. And by uniting multiple institutions to serve teens in a collective approach, we could build teen audiences for several organizations simultaneously under one umbrella. Teens could engage with these many organizations under one easily recognizable brand.

For the first year of the program, we aimed to offer admission to twelve museums and sign up 1,000 teens for a pass, resulting in 1,400 museum

visits. We planned to measure our success in terms of our ability to reach those numbers, as well as public perception of the program and endorsements from key civic groups and city leaders.

IMPLEMENTATION

In order to launch this ambitious initiative, we first needed funding. Philanthropists Virginia and Harvey Kimmel generously came on as lead sponsors for the program, and to date, STAMP has received grants and sponsorships from the Hess Foundation, John S. and James L. Knight Foundation, Lomax Family Foundation, National Endowment for the Arts, the Philadelphia Foundation, Victory Foundation, Wells Fargo, Wyncote Foundation, and 25th Century Foundation.

In winter 2013, we began recruiting museums. We first held an informational session for a wide group of institutions to gauge their interest in participating and then followed up with individual meetings. In all, we met with seventeen museums and invited thirteen to submit an application. Ultimately, we selected the African American Museum in Philadelphia, the Barnes Foundation, Eastern State Penitentiary, Fabric Workshop and Museum, Institute of Contemporary Art, Mütter Museum of the College of Physicians of Philadelphia, National Constitution Center, National Museum of American Jewish History, Penn Museum, Pennsylvania Academy of Fine Arts, Philadelphia Museum of Art, and Philadelphia Zoo. Museums were selected based on interest and capacity to serve a teen audience. We convened these museums over summer 2013 to provide more information, discuss technology options, and schedule events. Each museum receives a stipend of $1,000 for participation in the program, and a small stipend toward producing their STAMP event ($250 in Year 1; adjusted to $350 to $450 in Year 2).

We also spent the summer of 2013 evaluating potential pass technology vendors and ultimately chose SwipeIt, a firm based in Massachusetts. The ability to track pass usage in weekly visitation reports from SwipeIt was the major influencing factor in our decision, as well as their offer of multiple pass redemption options to meet the needs of all participating museums.

We decided to build the website largely in-house, using a template from the WordPress blog platform. We hired two vendors to help with areas that were beyond the capabilities of our staff: implementing design theming and building the online sign-up form for the pass.

Throughout the summer, we also met with key school leaders and community groups to get feedback and ensure their partnership in promoting the program. We engaged a group of Philadelphia arts and culture organizations that offer teen programming and also separately convened

a group of non–arts community organizations that had experience and a history of success serving teen audiences. This list included over forty organizations such as PhillyRising, Big Brothers Big Sisters, and Mastery Charter School.

Throughout the spring and early summer of 2013, we recruited members for our Teen Council. Teens with a strong interest in arts and culture were encouraged to apply. Applications sought basic information (name, parent/guardian info, age, grade, school, GPA, extracurricular activities) in addition to essay questions, and a reference from a non-family teacher, mentor, or advisor. From the forty applicants, we invited eleven students to join the original council. Teen Council members receive a small stipend for their time and participation.

The Teen Council's first meeting took place in June 2013, where we laid out our expectations in regard to their responsibilities for the program. The council also developed a code of conduct in cooperation with Cultural Alliance staff. The council convened twice a month to work on initial activities such as naming the program; giving input on the logo design; and helping to plan and promote the October launch party. Throughout the rest of the year, the council continued to meet twice a month to visit museums; pitch and write monthly blog posts; develop a social media strategy; assist in planning and promoting events; and write and film *STAMP: The Starter's Guide*, a short film made in partnership with Philly in Focus, ExpressWay Productions, and the Barnes Foundation, as a way for the Teen Council to explain museum etiquette to their peers.

In October 2013, STAMP officially launched with a party for teens at the African American Museum in Philadelphia, after a soft launch online the week prior. Teens who attended could sign up for a pass at the event and participate in a "scavenger hunt" to visit the activity tables of each museum. Around four hundred teens attended the event, and the launch received a great amount of press.

Once STAMP launched, we had to manage the flood of online sign-ups and mail passes in a timely fashion. We surpassed our original goal of signing up one thousand teens within the first week. We anticipated that sign-ups would slow down after the first few months, but when they did not, we hired a STAMP Fellow to help with mailings and other aspects of the program.

Throughout the year, we held events at a different museum each month. These party-like events were meant to help teens view museums as a fun social experience. The more successful events were a teen toga party at the Penn Museum, a dance party at the Philadelphia Museum of Art, and a STAMP day in conjunction with the Mütter Museum's National HIV Testing Day festivities.

We also offered two professional development opportunities in order to support our museum partners in serving this new audience: a "Serv-

ing Teen Audiences" workshop in August 2013, which was designed to help break down barriers and stereotypes about teens, and an "Engaging Teens in the 21st Century" workshop in June 2014, which was open to the entire cultural community. "Engaging Teens in the 21st Century" featured Danielle Linzer, the Whitney Museum of American Art's manager of access and community programs, who presented findings from a national research initiative investigating the long-term impact of teen programs in contemporary art museums.

In August 2014—having signed up over eleven thousand teens—we closed sign-ups temporarily, in preparation for Year 2. In advance of the official launch of Year 2 on September 1, 2014, we held an event at the Philadelphia Museum of Art, in partnership with the City of Philadelphia's Office of Arts, Culture, and the Creative Economy and the city program Fun Safe Philly Summer. During the party, we announced new Year 2 components: new Teen Council members, three additional museums (the Franklin Institute, Academy of Natural Sciences of Drexel University, and Philadelphia History Museum) and the STAMP Bucks loyalty program, where teens can earn points redeemable for prizes each time they use their pass. Mayor Michael Nutter also attended the party, delivering a rousing speech in support of the program and even snapping selfies with teens.

Running STAMP has required six full-time staff members (from our Community Engagement, Programs, and Development departments); two part-time fellows; two part-time interns from WorkReady, a city program that matches high school students with summer internships; marketing and visitor services staff at the participating museums; Teen Council members; and our design and technology vendors. Expenses for STAMP in FY14 (July 1, 2013–June 30, 2014) totaled $178,749, with the top expenses being personnel, design, equipment, and printing.

The challenges in launching and maintaining this program have been significant. In Year 1 we had a relatively small budget. (We actually received additional revenue for STAMP in FY14 that was restricted and was not "released from restriction" until FY15.) And due to the small size of the Cultural Alliance's staff, with the exception of part-time interns, none of our STAMP program team members work exclusively on STAMP.

There have been logistical challenges as well, such as communicating to school groups that museums cannot honor the pass for field trips. We were careful to make sure that STAMP would not infringe on museums' group admissions sales. Additionally, it was challenging to find travel solutions for low-income students. To address this issue, we partnered with Independence Visitor Center Corporation to offer free rides on the PHLASH trolley for STAMP passholders during its operational months. Conversations with Southeastern Pennsylvania Transportation Authority (SEPTA) to coordinate free or discounted rides on city buses and subways were unsuccessful in Year 1.

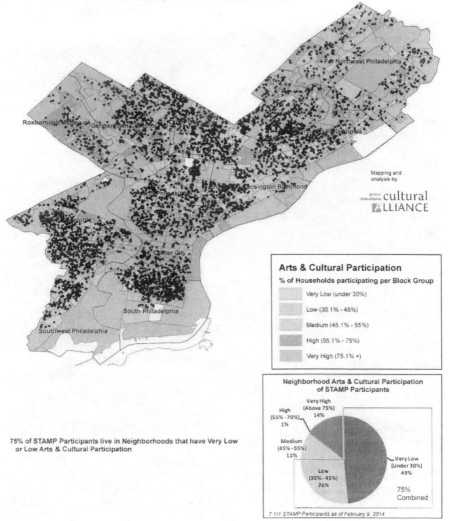

STAMP Participants and Arts & Cultural Participation

Location of STAMP Participants and the Levels of Arts & Cultural Participation
in the Neighborhoods Where They Reside

Mapping and
analysis by:

greater
philadelphia cultural
ALLIANCE

Arts & Cultural Participation

% of Households participating per Block Group

Very Low (under 30%)

Low (30.1% - 45%)

Medium (45.1% - 55%)

High (55.1% - 75%)

Very High (75.1% +)

75% of STAMP Participants live in Neighborhoods that have Very Low
or Low Arts & Cultural Participation

**Neighborhood Arts & Cultural Participation
of STAMP Participants**

Very High
(Above 75%)
14%

High
(55% - 70%)
1%

Medium
(45% - 55%)
11%

Low
(30% - 45%)
26%

Very Low
(Under 30%)
49%

75%
Combined

7,111 STAMP Participants as of February 9, 2014

Figure 3.2. Map showing STAMP participants in Philadelphia neighborhoods (as of
February 2014) as compared to arts and cultural participation rates in their neighbor-
hoods. Seventy-five percent of STAMP participants live in areas with low arts and cul-
tural participation.

RESULTS

The first year of STAMP wildly surpassed our expectations. With over 11,000 teens enrolled and 2,562 visits by the end of Year 1, we consider the program a huge success. In a midyear analysis of the data we collected with sign-ups, we found that STAMP has been successful in reaching youth from neighborhoods with traditionally low cultural participation, with over 75 percent coming from such areas. Furthermore, 58 percent of passholders are African American or Latino, and 47 percent come from economically disadvantaged households.

We also received positive feedback from the teens and museums participating in the program. Teen Council member Jordan Deal told us, "STAMP has given my fellow peers the chance to become culturally active teens who can venture out and inspire others in the arts. The STAMP Pass has become a network that will impact Philadelphia's art and culture for many generations to come." And in August 2014, Philadelphia Museum of Art staff member Damon Reaves told the *Philadelphia Inquirer*, "We've seen good results the first year," and "Now, we're thinking about what we can do in terms of programs, what are we going to offer."

STAMP has also seen tremendous public support, with over 424 individual donors pledging to sponsor a teen on #GivingTuesday 2013, commendations from Mayor Nutter and City Council members, and a 2014 Art-Reach Commitment to Cultural Access Award. Several Cultural Alliance member organizations have also come forward to offer additional opportunities for STAMP teens, such as theater tickets and classes.

LESSONS LEARNED

There are two crucial pieces of advice we would offer to other organizations interested in launching a program like STAMP. The first is to engage teens in your planning. Our Teen Council lends authenticity to STAMP and has been vital in providing feedback on what will and will not work with their peers. Second, it is extremely important to engage partners and encourage a reciprocal, mutually beneficial relationship where value is seen by all parties. Without our partners, there is no way STAMP would have achieved the reach it has, or would be able to offer such diverse offerings for Philadelphia teens.

In Year 2 there are a few things we hope to do differently. For one, if we can find room in our budget, we would like to use an outside vendor for all pass mailings. We also would like to do more frequent analysis of STAMP data. We believe a deeper analysis of usage trends would not only be valuable for further demonstrating the success of the program, but also to help other organizations improve their teen programming.

DRILLING DOWN: WHAT'S NEXT?

Provided funding and support continue to grow, we believe the program is sustainable and will continue to fit within the Cultural Alliance's strategic priorities. There are thousands of Philadelphia teens we have yet to reach, and we hope to expand the program in subsequent years by recruiting other cultural institutions (beyond museums) to offer ongoing free access for passholders. We would also like to connect teens to the cultural workforce through internship programs with STAMP museums.

One of the bigger challenges we now face is growing usage numbers for the pass. We anticipated a divide between the number of sign-ups and the number of visits, but would like to see how we can begin to close the gap. We hope the STAMP Bucks loyalty program will help, as well as large-scale events that engage multiple museums. For example, we are planning a "STAMP on the Parkway" event for spring 2015, which will involve the Franklin Institute, Academy of Natural Sciences, Philadelphia Museum of Art, and the Barnes Foundation. Our hypothesis is that these larger events will be more enticing for teens and attract greater public and media attention. Another focus is exploring ways in which our Teen Council and other passholders can be better brand ambassadors for STAMP via social media.

Overall, despite these challenges, we already see the potential for STAMP as a model program for other communities across the country and have begun thinking about how we could put that concept into action.

RESOURCES

Catterall, James S., Susan A. Dumais, and Gilliam Hampden-Thompson. "The Arts and Achievement in At-Risk Youth: Findings from Four Longitudinal Studies." National Endowment for the Arts Research Report #55, 2012. arts.gov/sites/default/files/Arts-At-Risk-Youth.pdf.

Denver Art Museum. "Creativity, Community, and a Dash of the Unexpected: Adventures in Engaging Young Adult Audiences." 2012. denverartmuseum.org/sites/all/themes/dam/files/final_report_to_the_field_1.16.2012_final.pdf.

Scales, Peter C., Eugene C. Roehlkepartain, and Peter L. Benson. "Teen Voice 2009: The Untapped Strengths of 15-Year-Olds." Best Buy Children's Foundation. www.search-institute.org/sites/default/files/a/TeenVoiceReport_FINAL.pdf.

Seattle Teen Tix. Accessed September 16, 2014. www.teentix.org/.

"Teen Programs How-To Kit." Walker Art Center. media.walkerart.org/pdf/wac_teen_kit_booklet.pdf.

FOUR

#CulturalHeritage

Connecting to Audiences through Instagram

Margot Note, World Monuments Fund

Launched in 2010, Instagram is a mobile social network application that allows users to take pictures and videos; apply different tools, filters, and frames to them; and share them on the application itself or through other social networks. Due to its visual nature, Instagram has become a creative marketing tool for social media–savvy companies, including museums. This chapter outlines how a cultural heritage organization began its Instagram account and developed best practices, as well as the steps that may be taken to replicate the institution's success with this image-intensive social software.

PLANNING

World Monuments Fund (WMF) is a nonprofit organization devoted to saving the world's treasured places. For fifty years, working on six hundred projects in over one hundred countries, it has conserved architectural sites through partnerships with local communities, foundations, and governments. Headquartered in New York City, the organization has offices and affiliates worldwide.

WMF has amassed a robust image collection in the course of documenting projects at sites as diverse as Versailles, Petra, and Angkor Wat. The images represent themes related to the preservation of architectural heritage, capacity building and tourism management, education, and disaster recovery.

WMF functions similarly to museums through its field projects, training programs, publications, and events. Because the organization has activities throughout the world, the Internet serves as its public face. Im-

43

ages are accessible through WMF's website and Flickr account as well as collaborations with Google and ARTstor.

WMF has yet to optimize its website for mobile use; thus, the organization sought alternatives to connect with audiences through smartphones. Instagram is the first born-mobile app and a leader in visually representing organizations. Images, as the most shareable content online, introduce institutions to new audiences. In regard to engagement rates, a Forrester Research study found that Instagram was superior to any other social network with a rate of 4.21 percent as compared to less than 0.1 percent for others.[1] By combining the technology trends of mobile use and photo sharing, Instagram gained over 200 million users, with 50 million added in a recent six-month period.[2]

For most institutions, maintaining standard social media platforms like Facebook and Twitter is time-consuming. Expansion to other applications requires consideration of whether the additional effort is worth it. Since Instagram was new for WMF, resistance was expected. Some staff members felt that the app might replicate WMF's work on Flickr. Flickr relies on a traditional model of photography where users take pictures with cameras, edit and process them, and display them in albums. Instagram, by contrast, exploits smartphone features to merge these steps into a workflow that prioritizes instant publishing. Flickr's popularity is on the wane, and the site lacks Instagram's mobility. Others thought that the "insta" nature of the app might make images of past projects seem disingenuous. Instagram users, however, do not always share images immediately; they often upload photos taken hours, days, or years earlier.

WMF expected a thousand followers for its first year, a modest estimate in retrospect. The organization targeted audiences interested in art, architecture, world history, and travel. Our Instagram account would promote WMF's mission and provide an opportunity for viewers to experience a sense of place, especially for monuments that are far away, inaccessible, or lost.

IMPLEMENTATION

The World Monuments Fund Instagram account (@worldmonuments-fund) started in September 2013 in anticipation of our annual gala and after-party the following month. Since the after-party attracts tech-savvy donors, WMF wanted to document their experiences through an event hashtag. Around this time, the biennial World Monuments Watch was issued. This list of cultural heritage sites at risk creates international press coverage for the organization. The announcement was also an opportunity to gain followers.

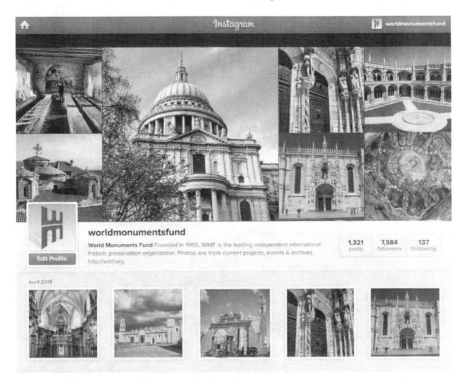

Figure 4.1. The World Monuments Fund Instagram account started in September 2013. Through Instagram, @worldmonumentsfund provides audiences with glimpses of what it is like to preserve treasured places. Each Instagram photo acts as a locus for interaction with our users.

Technology and assets needed to implement Instagram include photographs in JPEG format, a computer to access the photographs, an iPhone or similar device, and a staff member to administer the account. Because I oversee our image collections, am familiar with Instagram from personal use, and initiated the project, I volunteered to manage the account. Most organizations task junior staff members with social media maintenance. Since the account was new and needed to convey complex themes, I felt that someone seasoned in the organization should administer it initially.

The first step in establishing an Instagram presence is creating a profile. Our Twitter handle is @WorldMonuments, shortened because of Twitter's 140-character limit, and @WorldMonuments on Instagram was already taken. Social media handles for organizations should be consistent, but using our full name on Instagram was the best choice. We added a profile picture of our logo and included statements about our mission and images in the bio section. The only place on Instagram with a clickable link is in the profile; we used our website address.

Steps for Creating and Sustaining an Instagram Presence

1. Download the Instagram app and set up an account.
2. Create a profile and connect to other social media platforms.
3. Add images and videos. Experiment with content to see what receives the best responses.
4. Create a publishing plan regarding posting frequency, timing, and content.
5. Use web-based programs to manage account and track engagement.
6. Follow Instagram accounts of partner organizations, donors, and influencers in the field.
7. Investigate what other organizations are doing on Instagram and replicate good content.
8. Build followers by adding hashtags and liking images.
9. Solicit comments and feedback by asking followers questions about their interests.
10. Create specific hashtags for the organization. Re-gram user-created content.

WMF teams work globally, though we maintain the account at our headquarters. Most images are taken with professional cameras in the past rather than camera phones in the moment. The workflow, therefore, is more complicated than using one device. After selecting images from our servers, I use my work computer to send the pictures to my personal e-mail account. I then open my e-mail message on my iPhone and save images to my Camera Roll. Next, I launch the Instagram app on my phone and upload the images. Occasionally, I e-mail myself captions because it is easier to type on the computer than on my iPhone.

The original pictures lack cohesion, but in Instagram, each photograph has the same square format and resolution. Instagram provides in-app options for editing, and twenty filters enhance photos. Editing and filtering is minimal because we dislike manipulated imagery.

We upload three related pictures per workday. We share views of the conservation process, shots during events, and alternative angles of well-known architectural sites. On Fridays before long weekends, WMF poses questions such as, "Why does architecture matter?" We welcome opportunities for followers to comment or provide feedback.

Instagram images look timeless and placeless, yet time stamps and geographic coordinates mark them. A dynamic time span that is relative between the present and the creation date organizes the images. For example, an image notes if it was posted one minute, one week, or one year ago. Instagram denotes localities by allowing users to share places

either by adding images to a photo map or tagging photos with locations. When we take real-time photos, we tag locations and utilize photo maps to discover similar images.

We feature current projects because of their frequent updates and fundraising needs. Photographs of completed projects are just as compelling because they reach new audiences. We regularly post photographs from our work in the 1960s and 1970s for #ThrowbackThursday, a weekly reminiscent photo movement on social media.

Captions and replies to comments are limited due to space. We identify places by name, city, and country and highlight our involvement. Our captions are in English because translated captions do not influence our engagement rates. If comments are written in a language other than English, we reply in the original language using online translation sites. Language keyboards on the iPhone allow site names, such as Eszterhàza Castle in Fertöd, Hungary, to retain their diacritics.

Emojis, digital ideograms that originated in Japan but are popular worldwide, add levity to captions. One emoji is a moai, which is a stone monolith carved by the Rapa Nui people. Moai are significant to WMF because Easter Island was one of our first projects, and our young professionals group is called the Moai Circle. We always include the moai emoji on posts about the group to members' delight.

Hashtags, words or phrases written without spaces or punctuation and preceded by the # sign, make tagged images visible to users that search for topics that interest them and can attract more likes and followers. We apply four to eleven hashtags because that range increases interactions significantly.[3] We use popular hashtags (#architecture) as well as those that reference location (#Venice). Before creating organization-specific hashtags, we check to see if they had been used previously.

Instagram is a reciprocal, participatory system, so liking others' images gains likes and followers. We like images that mention us or show sites we conserved. We search for hashtags such as #facades and like images that engage us.

Maintaining the account requires twenty minutes daily to post, like, and respond to comments. Designed for mobile devices, Instagram has rudimentary online capabilities. Programs drawn from Instagram's open application programming interface (API) help maintain the account from my work computer by determining the best times to post, finding supporters, and viewing what has worked previously.

RESULTS

WMF measures its success through metrics. Our growth—over 7,500 followers, 3,500 comments, and 250,000 likes—is phenomenal. We average

288 likes per image and five comments per image with highs of 532 and 23, respectively. Bimonthly statistics are compared to WMF's other social media platforms by percentages of followers gained. Instagram leads the rates of increased followers in most periods. During the first two months of the account, WMF had periods with an 81 percent, 63 percent, and 48 percent increase in followers. Our two-week follower growth average is 19 percent, with the lowest at 3 percent.

Success is measured subtly too. Trustees and donors are impressed with our social media activities. Colleagues informed us that our account was mentioned at board meetings, in conferences, and at sites. During a recent donor survey, a respondent wrote, "My connection to and awareness of WMF's activities has come primarily through the organization's Instagram account. . . . I would like to donate a small amount of money online directly to a specific project based on an Instagram post description that moves me."

A recent direct mail campaign sent to new, current, and lapsed donors incorporated our account. On one side of the mailing, we arranged our most liked images in an Instagram-like grid with the tagline "You already like the places where we work. Now join us and help ensure their future." The reverse featured a picture of one of our sites with comments from our followers. Using a familiar social media format offered a new way to tell our story, displayed the breadth of our work, and presented a creative spin on a traditional solicitation.

LESSONS LEARNED

WMF tweaks images to fit Instagram's style. Images captured by professional photographers look stilted in Instagram while images snapped by our project managers, all novice photographers, seem authentic. While architectural marvels illustrate our annual reports, Instagram enables shots used in internal reports to take center stage. Everyday images blur the division of amateur and professional image making, and Instagram showcases images that had previously only been viewed by a select few.

Several image qualities promote engagement on Instagram. Images with increased lightness, a high amount of background space, a dominant color, low saturation, and high texture receive more likes than their opposites; blue images generate more likes than red images.[4] While our image selection is more subject- than feature-related, these preferences may explain why followers like some pictures more than others. Studies have shown that human faces are 38 percent more probable to receive likes and 32 percent more apt to attract comments than pictures with no faces.[5] Pictures of conservators, locals, and event attendees balance our technical work and celebrate those who make our projects possible.

DRILLING DOWN: WHAT'S NEXT?

Looking toward the future, Instagram has potential for fundraising. If Instagram enables click-through support for links in captions, WMF may experiment with fundraising through the account. Our relationship with followers may result in contributions, but we currently lack the ability to track donor conversion rates.

We plan to increase the number of posts that are created directly using Instagram. Social media raises questions as to how far institutions are willing to relax their authority. By being more transparent in our information delivery, WMF and other cultural heritage institutions will stay relevant in a changing world. As staff members become more familiar with social media, we anticipate receiving more real-time images.

We also wish to incorporate more videos into WMF's Instagram account. Launched in June 2013, video sharing allowed users to record and share fifteen-second videos. We have created slideshow videos and will continue to experiment in the future.

WMF's Instagram workflow is sustainable because it does not require much upkeep. When the account was launched, we concentrated on gaining a foundation of followers. Now that this has been achieved, constant attention is unnecessary. The feed is successful because I was willing to perform the work myself. When someone else takes over the account's management, they will hopefully be able to maintain our growth.

Through Instagram, WMF provides audiences with glimpses of what it is like to preserve treasured places. Each Instagram photo acts as a locus for interaction with our users. The account bolsters relationships with people that are passionate about our cause and raises awareness for prospective donors. WMF uses Instagram to promote conservation and its relationship to communities while highlighting our successes and vision for the future. We hope to continue our Instagram account for many years to come.

NOTES

1. Nate Elliot, "Instagram Is the King of Social Engagement," 2014, blogs.forrester.com/nate_elliott/14-04-29-instagram_is_the_king_of_social_engagement.

2. Instagram, "Instagram Today: 200 Million Strong," 2014, blog.instagram.com/post/80721172292/200m.

3. TrackMaven, "The Fortune 500 Instagram Report," 2014, pages.trackmaven.com/rs/trackmaven/images/TM_Fortune500_Instagram_Report.pdf.

4. Curalate, "6 Image Qualities Which May Drive More Likes on Instagram," 2014, curalate.tumblr.com/post/68079619904/study-6-image-qualities-which-may-drive-more-likes-on.

5. Saeideh Bakhshi, et al., "Faces Engage Us: Photos with Faces Attract More Likes and Comments on Instagram." Paper presented at the Conference on Human Factors in Computing Systems, Toronto, Canada, April 26–May 1, 2014.

RESOURCES

Hu, Yuheng, Lydia Manikonda, and Subbarao Kambhampati. "What We Instagram: A First Analysis of Instagram Photo Content and User Types." Paper presented at the Conference on Weblogs and Social Media, Ann Arbor, MI, June 2–4, 2014.

Kaufman, Leslie. "Sharing Cultural Jewels via Instagram." *New York Times*, June 18, 2014. Accessed August 18, 2014. www.nytimes.com/2014/06/18/arts/design/sharing-cultural-jewels-via-instagram.html.

McNely, Brian J. "Shaping Organizational Image-Power through Images: Case Histories of Instagram." Paper presented at the Professional Communication Conference, Orlando, FL, October 8–10, 2012.

Miles, Jason. *Instagram Power: Build Your Brand and Reach More Customers with the Power of Pictures.* New York: McGraw-Hill Education, 2013.

Weilenmann, Alexandra, Thomas Hillman, and Beata Jungselius. "Instagram at the Museum: Communicating the Museum Experience through Social Photo Sharing." Paper presented at the Conference on Human Factors in Computing Systems, Paris, April 27–May 2, 2014.

FIVE

How the Boca Raton Museum of Art Captures Attention and Shifts Perspectives

Marisa J. Pascucci, Boca Raton Museum of Art

Located halfway between Palm Beach and Fort Lauderdale, Florida, the Boca Raton Museum of Art[1] is situated in a notorious yet utterly distinct region of the country. Year-round residents, seasonal "snowbirds," international tourists, and boundless vacationers . . . Boca Raton has it all. So what is our secret for engaging each unique sector of this growing region while simultaneously attracting new audiences? The answer is simple: by presenting exhibitions that strike a careful balance between time-honored art historical ideals and contemporary innovation.[2]

Rooted in the history of its city, the Boca Museum's genesis dates to the late 1940s, when a group of socially active women joined together to form Boca Raton's first organization, a civic club with the initial goal of building a small library. Two philanthropic members of this burgeoning library club were appointed to organize an open house. Held in the Town Hall, with an estimated one thousand people in attendance, this inaugural event also included a modest exhibition of paintings borrowed from friends and loaned by galleries from Palm Beach to Miami. Given the success, the library club decided to form a parallel organization to further the residents' interest in the fine arts and by 1950, the Art Guild of Boca Raton was founded.

By 1962, the Art Guild built and dedicated its first building. A decade later, the Art Guild officially became a not-for-profit corporation and in 1985 changed its name to the Boca Raton Museum of Art. In January 2001 with the redevelopment of downtown Boca Raton, the museum moved from its original building to its current, 44,000-square-foot facility in Mizner Park, which was recently voted one of the "Top 10 Great Public Places" by the American Planning Association. At this time, the original building became solely devoted to the museum's art school, which today

offers over one hundred weekly classes in all disciplines for children and
adults.

Concurrent to exhibitions, the museum presents a robust range of
education, outreach, and collaborative programs and events geared to
different scholastic levels that address wide-ranging community needs.
Museum visitors also enjoy the collection, which includes over five
thousand works of art and continues to grow. With strong holdings in
late nineteenth- to twenty-first-century European and American prints,
drawings, paintings, sculpture, and photography, the museum strives
to present key examples of modernism and contemporary art as well as
non-Western art and artifacts in our African and pre-Columbian galleries.

PLANNING

Before my employment in June 2012, the museum's galleries were marked
by the conventions of chronological installations, long (and authoritative)
didactic labels, limited seating, and severe pin-spotted lighting.[3] The mu-
seum has faced challenges in recent years as board members, patrons, and
the general membership began to reach the over-seventy-five age demo-
graphic. To capture and maintain the attention of the younger population
of families and young professionals who have made Boca Raton their
year-round home while simultaneously satisfying the tastes of our long-
standing "snowbirds," each department of the museum began rethinking
their current operational methodologies to demonstrate how visiting an
art museum is just as captivating and entertaining as the beaches, outdoor
leisure activities, shopping, and restaurants that make south Florida such
an attractive vacation locale.[4]

IMPLEMENTATION

The implementation of an innovative exhibition schedule at the Boca
Raton Museum began in the summer of 2012 with the thoroughly uncon-
ventional exhibition *Big Art: Miniature Golf.* While enticing visitors with
a fully playable miniature golf course experience within the galleries, the
exhibition also seamlessly (and subtly) explored the fusion between con-
temporary art and design and sports. A call to artists across the United
States was distributed in December 2011, and the exhibit was on view
July 18 through October 7, 2012. The diverse selection of artist-created
miniature golf holes included an orbit around the sun into a black hole;
a maze of brightly colored inflatable pool toys; and the world's smallest
version of the world's largest miniature golf course. Volunteers from lo-

cal high schools served as instructors during peak hours on late-night Wednesdays and the weekends. *Big Art: Miniature Golf* did just what it was intended to do—attract atypical museumgoers with the whimsical and playful side of contemporary art.

For visitors seeking a more traditional art museum experience, I curated a companion exhibition, *A Little Birdie Told Me* It carried the tongue-in-cheek tagline of "If chasing birdies on the mini golf links isn't your style, there's plenty to be found at the complementary exhibit, *A Little Birdie Told Me*" The exhibition featured a selection of avian imagery drawn from the museum's collecting areas of American and European prints and photographs and Native American and pre-Columbian objects. The exhibition included three categories of bird-inspired artwork: birds in flight, ethereal depictions, and abstract art (where finding the birdie proved more elusive than on the miniature golf course).[5] While the summer months historically delivered the lowest attendance figures for the museum, this particular summer bucked the trend, attracting more first-time, family, and intergenerational visitor groups than ever before.

Building on this momentum, the next suite of exhibitions merged interactivity with technology. From October 24, 2012, through January 13, 2013, the Boca Raton Museum was the first stop on the multiyear tour of *The Art of Video Games*, from the Smithsonian American Art Museum and guest curated by Chris Melissinos. The exhibition explored the forty-year evolution of video games as an artistic medium, paying particular attention to the astonishing graphics, captivating storytelling, and player interactivity indicative of the genre. It featured eighty video games presented through video footage of interviews with developers and artists (playing at ten viewing stations), twenty interactive kiosks with historic game consoles, four cases of original preparatory artwork, and five playable game stations.

Since *The Art of Video Games* was a technology-intensive exhibition, an outside exhibition designer was hired on a contractual basis. To bring the multitude of components together visually into a unified whole, he changed many gallery lights to BoGo lights casting the familiar maze of Pac-Man onto the floors and designed vinyl graphics that reinforced the historical progression of the video game era. A major sponsor was found for the exhibition which met particular technology needs (two projectors and ten flat-screen monitors) that have been used in subsequent exhibitions. *The Art of Video Games* called for additional volunteers to serve as gallery attendants. These attendants ranged in age from high school to the millennials, and each possessed extensive knowledge of and experience in playing video games. Identified by prominent name badges, this select group of volunteers were there to answer questions and offer instructions pertaining to the playable games and kiosks.

For balance, the museum's curator of contemporary art, Kathy Goncharov, curated a companion show of paintings and optics by Michael Zansky in an adjacent gallery. Zansky finds his inspiration in popular culture and is captivated by puzzles, science, and storytelling, all quite similar to a video game programmer, making his work an apt companion to *The Art of Video Games*. Like many video games, his work includes apocalyptic visions, fantastic landscapes, and human-animal hybrids. In Zansky's absurd tragic-comic world, games of chance are constantly being played, where Harpo, Curly, Moe, Stan Laurel, W. C. Fields, Ramses II, Voltaire, and slapstick comedians join theoreticians of Western civilization and prehistoric creatures to ponder the puzzles of the universe. The use of optics, illusion, and movie characters is particularly fitting, as Zansky has had a long career as a scenic artist for film and television.

Another endeavor by the Boca Raton Museum to present a diversified coupling of engaging exhibitions involved the traveling exhibition *Afghan War Rugs: The Modern Art of Central Asia* (in Boca renamed *Afghan Rugs: The Contemporary Art of Central Asia*) and *Elaine Reichek: The Eye of the Needle*, May 3 through July 27, 2014. For this coupling of shows, Kathy curated an exhibition of knitted and embroidered artworks with a conceptual twist by Elaine Reichek. The exhibition focused on the period of Reichek's art dating from 1972 to 1995 and addressed the translation, and mistranslation, of artifacts from outside cultures. Reichek finds, enlarges, and colors ethnographic and architectural photographs such as those by Edward Curtis and Walker Evans, pairing them with her own hand-knitted interpretations. Photographs of teepees, ceremonial dress, and others are juxtaposed with knitted forms that mimic the images found in them. The use of knitting and embroidery is central to Reichek's work. As she says, "The meaning of an artwork is always bound up with its media and processes and their history." This statement perfectly sums up the link we were striving to create between the historic art of rug weaving that so pervades the essence of life in central Asia and contemporary art.[6]

Meanwhile, *Afghan Rugs: The Contemporary Art of Central Asia* offered forty rugs of exceptional quality and stunning imagery that introduced a unique category of decorative arts to our audience. These works of art presented the most untraditional of motifs, such as cityscapes, maps, portraits, guns, tanks, grenades, and missile launchers. Created by weavers in Afghanistan, or in the northwest frontier province of Pakistan, each rug was hand-spun, dyed, tightly knotted in wool, and traditionally framed by an intricately detailed border design.

Knowing that the imagery, as well as the art form, could be difficult for some visitors to experience and comprehend, I augmented the work of the guest curators, Enrico Mascelloni and Annemarie Sawkins, with the renowned photograph *Afghan Girl*, shot by Steve McCurry for the cover

of *National Geographic* in 1985,[7] a QR code to download the accompanying brochure for free, a social media monitor, and a comment wall. The brochure was filled with images of the rugs, photos of the Afghan landscape and people, a timeline, and two thorough commentaries by the organizing curators. Recognizing the value of the information and images beyond our presentation of the exhibition, we decided to print only a dozen copies of the brochure for visitors to review in the galleries and then made it available as a free download either through a QR code displayed in the galleries or on our website.

A social media monitor (instituted in January 2013 and installed for the first time within an exhibition space versus the museum lobby) swapped between Instagram and Twitter feeds to show all posted photos or tweets that tagged the Boca Raton Museum in any combination of #bocamuseum, #bocaratonmuseum, or #brma. The number of Instagram postings and tweets that showed or mentioned the Boca Museum increased tremendously with the insertion of the monitor in the gallery space, especially on those days when there were group tours from area high schools and colleges.

The comment wall was something new for us. I wanted a place for all visitors, whether social media savvy or not, to interact and reflect on the art and current political and social events. To give staff the ability to edit for inappropriate language, we provided Post-it notes and pencils

Figure 5.1. Comment wall and social media monitor installed adjacent to *Afghan Rugs: The Contemporary Art of Central Asia* at the Boca Raton Museum of Art, April 2014.

for visitors to write their thoughts and then stick them on a designated section of the gallery wall. The comment wall was a greater success than expected.[8] The Post-it notes were overflowing[9] with messages noting everything from the beauty of and appreciation for the art to political views and even the museum's collection galleries. An unexpected surprise was the number of sketches of the rugs and works in the museum's collection posted as well.

RESULTS

Overall, we are extremely pleased with the outcome of our revamped exhibition strategy from summer 2012 through 2014. For 2010–2011 yearly attendance hovered near 176,000; 2011–2012 near 178,000; and for 2013–2014 it was well over 180,000. Some members and benefactors that have been with the museum since its first dedicated building in 1962 have been understandably unreceptive to playing miniature golf and video games in the galleries. However, the increase in attendance and memberships shows us that our approach is succeeding. As part of the Boca Museum's funding from the Palm Beach Cultural Council, volunteers administer surveys detailing the visitor experience and effectiveness of marketing. The positive comments taken have also attested to the success of our varied exhibitions.

The multigenerational visits are proven by such tweets as "Loving @bocamuseum with the best grandma in the world!"; "@BocaMuseumOfArt we loved it. He was counting down the days until I took him. Thanks for have an amazing exhibit"; and "@BocaMuseumOfArt My whole family loved #taovg [The Art of Video Games]! We enjoyed the quilts and one of my daughters is studying Africa so that art was neat." The younger demographic has voiced their approval via social media as well: "@Bocamuseum #TurnUp #Swag #Yolo #Artiscoolbrah."

The postings to the comment wall were just as affirming—as simple as "POWERFUL" to such sophisticated and erudite messages as "Art is a way to communicate. Thank you for exposing us to an art form from a culture that many of us do not understand. Through art, we can be better connected." The desire of our visitors to learn more about and connect with *Afghan Rugs* was proven by the number of downloads of the exhibit brochure, 353 times during the exhibition's three-month run.[10]

LESSONS LEARNED

From the rise in our attendance and positive feedback, we have learned that a progressive exhibition schedule with moderate to extreme levels of

visitor interaction confirms that an art museum can truly compete with the abundance of highly desired outdoor activities and social engagements available in south Florida. When given the opportunity to experience art through varied platforms, the demographic that has supported the museum for decades (through financial contributions and repeated visits throughout the year) will continue to support its new participatory and educational initiatives. Accordingly, the Boca Raton Museum of Art will continue to create, implement, and seek out new, creative approaches for experiencing the art presented in our exhibition and collection galleries. Even as the museum experienced a change in leadership in early 2014 with the departure of a director, the mandate to revitalize the art museum experience continues seamlessly.

DRILLING DOWN: WHAT'S NEXT?

Beginning in late 2014, the curatorial department launched a regular series of video art installations beginning with Shizuka Yokomizo's *Forever (and Again)*. This work shows four elderly female pianists, each over seventy years old, playing Chopin's waltz with relation to the passage of time and memory. This near life-size projection was paired with *Theresa Bernstein: A Century in Art*, an exhibition of over forty paintings by a female artist that accomplished the truly awesome feat of making and exhibiting art with a great deal of success in every decade of the twentieth century. Incorporated into the Bernstein installation were QR codes linking to YouTube videos of interviews with the artist and those who knew her. Additionally, there was an iPad station to peruse the videos and companion website for those visitors without smartphones. Several copies of the abundantly illustrated, multi-essay exhibition catalog were also available for relaxed review in a comfortable reading area.

Four simultaneous exhibitions were on view from November 11, 2014, through January 11, 2015 (the beginning of the "height of season" in southeast Florida): *Elliott Erwitt: Photography*; *Bryan Drury: Terrestrial Visions*; *New York Photographs from the Collection*; and *Latin American Artists and the Human Form*. This suite of exhibitions offered aspects of the classic and participatory approaches to experiencing art, while the work included the tradition of American painting and historic photography to contemporary art's experimental side of video media. The board of trustees and staff of the Boca Raton Museum of Art will continue to work to present the unique experience of one-on-one contact with art in the best light and as a viable option for an all-ages experience for the resident and tourist community of southeast Florida and beyond, thereby shifting the perspective of what it is to experience art within a museum's walls.

NOTES

1. Fully accredited by the American Alliance of Museums and now in its sixty-fourth year, the Boca Raton Museum has an established history of well-recognized exhibitions and programs that attract over 180,000 yearly visitors.

2. I send a profound thank you to Annagrace Pfister, member engagement manager, for sharing relevant grant-reporting information and serving as a reader of this chapter. My gratitude extends also to the curatorial department for providing information: Kathy Goncharov, curator of contemporary art; Martin Hanahan, registrar/exhibitions manager; and Kelli Bodle, assistant registrar.

3. The Boca Museum has slowly replaced pin-spot lights with an even, over-all lighting style. We also replaced benches with backed chairs and couches and placed relevant art books in galleries to create a space for leisurely reading and comfortable congregation for our visitors.

4. In 2012, the museum's then director and board of trustees expanded the curatorial staff, expressing their strong commitment to the collection and exhibition schedule and our visitors' experience with both, along with a complete re-branding campaign. The expansion also came with the directive of reaching new audiences through an entertaining and revitalized approach to experiencing art. Kathy Goncharov, curator of contemporary art, works to augment the exhibition schedule by presenting a balance of progressive and traditional exhibitions. And I, as curator of collections, rework the collection galleries, moving beyond the di-dactic history of art to create mini-exhibitions and to tell clever stories through art. It is through the intermingling of exhibitions and complementary programming conceived by the staff as a whole that the museum strives to give each visitor an "a-ha" moment at every turn of the corner in the galleries.

5. The list of artists included: Wolf von dem Bussche, Manuel Carrillo, José Luis Cuevas, Max Ernst, Joan Miró, Philip Pearlstein, Man Ray, James Rosenquist, and Ben Shahn along with an Inuit carved marble statue, a Native American carved stone, and a Peruvian anthropomorphic vessel.

6. For images of the exhibitions discussed, and additional exhibitions not presented due to space constraints, visit www.bocamuseum.org/exhibitions.

7. The museum's collection includes a photo from the 2007 edition.

8. For additional assessment on the comment wall and social media feed as it pertained to *Afghan Rugs: The Contemporary Art of Central Asia*, visit www.bocamuseum.org/blog for "The Viewer Talks Back," posted April 30, 2014, by Aleksa D'Orsi, curatorial intern.

9. Out of the dozen three-by-five-inch, 100-page Post-it notepads made available during the run of the exhibition, three notepads were left unused at the time of de-installation.

10. Of the six hard-copy versions mounted to Plexiglas holders available on the benches in the exhibition, four had to be replaced, as visitors seemed to have left with them—all of which indicates the success of the exhibition and that visitors are receptive to receiving information in an innovative, and at times unconventional, format. The brochure will remain available indefinitely on the Exhibition Archive page of the website.

RESOURCES

Evans, Catherine, Sebastian Chan, Kathleen McLean, Christina Olsen, and Nina Simon. "Participation, Engagement and the Curator." Papers presented at the annual meeting for the Association of Art Museum Curators, May 7, 2013. (Video recording of the conference available to AAMC members at www.art-curators.org.)

Simon, Nina. *The Participatory Museum*. Santa Cruz: Museum 2.0, 2010.

Six

Expanding Family
Access and Engagement
in an Historic House Museum

A.B.C.D.E.

Janet Sinclair, Stansted Park, U.K.

This mnemonic presents an approach to historic house (HH) interpretation that summarizes this chapter: Access Balanced by Conservation, Display, and Engagement (encompassing Education and Entertainment). If historic objects and interiors are not conserved, there is no display nor means of engaging through direct contact with unique, authentic artifacts. Access, the justification for the survival of the HH, must be balanced by curatorial concerns.

Stansted Park is an Edwardian house in southern England, given by the Tenth Earl of Bessborough (d. 1993) to Stansted Park Foundation (SPF), a charity established to preserve and share with the public his former family home and its contents. SPF hosts approximately six thousand individual visitors, eight hundred organized school-age visitors, and several thousand event and corporate attendees per season.

The house contents comprise family portraits, antique furnishings, tapestries, books, and most notably, a fully furnished Edwardian servants' quarters. The ethos of the display presents the upstairs rooms as if the earl was still at home, and downstairs as if the servants were in residence. Though an appearance of nonintervention is engendered, deliberate curatorial decisions were taken to create this impression. Hence, though some (valuable) objects have been located further from the visitor's route, most are on open display neither with labels nor chronologically arranged. They tell stories by their context. Notices such as "Do not touch" or "do not sit" are used sparingly.

An HH cannot exclude those of any age who may touch, approach, or by implication, damage their unprotected contents. However, I will discuss how a proactive approach to creating family-friendly activities can both increase visitor numbers and educate while minimizing impact on this fragile environment.

PLANNING

The Stansted Proms were a major annual family-friendly event that took place in the grounds at SPF and served as a significant source of income that did not impinge on the house and its contents. However, in 2008, as a result of the global financial collapse, this open-air "Proms" concert weekend and its audience of several thousand was lost because the financial outlay was regarded by promoters as too great a risk against the chance of bad weather that might produce a low return from tickets.

Faced with this unforeseen loss of numbers and corresponding income, we made a decision to create a series of smaller family events spreading financial risk and attendances throughout the summer, using the house and grounds as a resource. This strategy involved little financial outlay and offered lower-, not higher-priced entry, aimed at attracting new and repeat visitors—particularly local families. Until then, a steady but not increasing number of such visits had been recorded.

In devising this strategy there were several concerns: budget, conservation, staffing, and attitudes of stakeholders, including other visitors. Surveys suggest that "Visitor Enjoyment diminishes when country houses are too crowded, too noisy, too busily managed, and the opportunity for quiet, personal enjoyment is lost."[1] Such strengths and weaknesses were identified and addressed as we devised a program. We hoped to increase numbers but also quality of visits and produce entertaining, informing outcomes for not only children but parents and grandparents, and SPF.

IMPLEMENTATION

The aftermath of the loss of the Stansted Proms[2] indicated a strong local demand for family-friendly events, demonstrated by hundreds of e-mails, calls, and letters received. Yet in creating new events, no new income was available. Varied ideas including illustrated quiz sheets were simple to organize, written for "readability," and appealing to all family members. A "Teddy Bears Picnic" to attract preschoolers, free guided walks through the arboretum, and open-air theater productions offered a contrasting family event every week to encourage repeat visits.

Open-air theater could not be weatherproofed. However, by aiming for audiences of 100-plus rather than 1,000-plus and by placing a contract with a production company that ensured a cut of the ticket income as a fee, SPF reduced its financial risk to zero. Related, stewarding and car parking by volunteers in return for a ticket minimized outlay while complying with operational concerns. First-time visitors were particularly attracted through free entry for mothers, with daffodils on Mother's Day, and free entry for fathers with a classic car rally on Father's Day.

Timeline

2009
Planned cancellation of major outdoor event

2009
Planning, timetabling, logistics, and costing of small-scale, family-friendly events: Teddy Bears Picnic, arboretum walks, storytelling, quizzes. Free on Mother's and Father's Day.

2009–ongoing
Volunteer recruitment, training: local marketing, press releases, newsletter

2009–2010
Partnership with small-scale, open-air theater groups; more House Open days

2010
Reduced prices for children; SPF signed up to "Kids in Museums" Manifesto

2011
More activities inside: Portraits Day, Teddy Trail, torchlit (Halloween) tours

2012
Free entry for children to events; more days per event; Facebook account set up

2013
Free August entry for children

2014
Marketing officer appointed

A recruitment campaign for volunteers is a preoccupation of HH museums. New leaflets were designed that did not specify roles. Rather, a general training program was set up in-house to include familiarization with the house, security, conservation, group management, and customer care. Volunteers made costumes for "Portrait Day" activities when children were encouraged to try on clothes inspired by eighteenth-century family portraits upstairs and servants' costumes downstairs. They devised a costumed "Teddy Trail" through the house.

Pricing initially offered activities free with standard admission. Family tickets became flexible to cover any size of family with lower prices for children (£1, approximately $1.50) for events. Later, free child admission

produced no loss of income, but greater goodwill as more parents and grandparents brought young people to activities. SPF's rural location means visitors arrive by car, so children cannot wander into the site, and unaccompanied children are not permitted in any of the paid-for site to comply with the Child Protection Policy and Accessibility Statement.

The mantra "Keep It Simple" governed implementation of the new programs and approaches. Technology was minimized for reasons including cost of infrastructure and lack of staff skills. Also, technology quickly becomes outdated and needs maintenance. Interactive screens would impinge on the atmosphere of the HH and distract from the impact of authentic contents. Basic IT supported in-house design and print of leaflets and quiz sheets, which were laminated to be reused in line with SPF's sustainability policy.

Some events (the "Mystery Objects" quiz and costumes) adapted SPF's existing provision for schools. Practical considerations included providing pencils and clipboards, and storage for equipment. Mirrors were an essential component of dressing-up activities when rules of "no photography" were relaxed. "Rewards" for completing a quiz or trail were minimal but appreciated: a certificate, postcard, pencil, or bookmark. Children in school groups were given a free return ticket in addition.

The financial crisis produced one positive outcome for U.K. visitor attractions, with the rise of the "staycation," a vacation spent enjoying local activities while staying at home. The government tourism organization VisitEngland reported the positive impact of this behavior from 2008.[3] By following a low-risk approach and targeting a local market, SPF benefited from this phenomenon.

In some HH museums, particularly private historic house museums where display rooms are used by a resident family even while open to paying visitors, "balancing" access to objects with the use and conservation of historic and fragile items becomes an operational issue. The question of access has received vigorous attention in the U.K. media recently with debate on the subject of even allowing families into museums.[4] This discussion followed an incident at Tate when children were not prevented by parents from climbing on a sculpture. In the United States, a recent discussion asked if it is okay to touch items and pointed to Glensheen and home museums as rethinking rules to lure visitors.[5] Such discussion about removing HH barriers prompted my response on a LinkedIn group: "Access and engagement need not compromise security and conservation, especially if it engenders a sense of 'ownership' among visitors. Careful planning and respect for the visitor as well as the object in an historic interior has been a key to increasing enjoyment and repeat visits at Stansted Park . . . Encouraging visitors to open & close room shutters to protect items from UV light is a science lesson as well as benefiting the artifacts."[6] This discussion continues as noted by recent press coverage.[7]

There is a strong sense of "ownership" among volunteers. At SPF a tolerant approach to younger visitors existed among some stewards but not all, so training and information sharing were built in to the implementation process. Stewards wore period (replica) servants' costumes but gave information in a third-person format, not as "first-person" interpreters. Volunteers' newsletters were introduced, and informal training sessions became compulsory. Importantly, these also included coffee and chat. Only after a season of mentoring and observation did the education officer select volunteers for the education team: not always ex-teachers!

Today IT plays a much larger part in interpretation, monitoring, and marketing. Smartphones carried by most young people enable QR (quick response) codes that remove the need for information stations by "attaching" objects to a repository of online material. However, at SPF and similar sites, full usage of Internet media is prevented by thick stone walls, or geography. As with the archetypal visitor wandering an exhibition with his or her nose in a catalog, media may become a barrier to experience of the authentic object, and to forming personal opinions, responses, and reactions.

RESULTS

The outcome of the new program was positive, measured by attendances and feedback. However, some aspects that were trialed were not repeated. What follows is an extract from my 2010 *SPF Report to Trustees*:

> Income from visitors increased sharply in 2009 and this increase has been sustained in 2010. Last year's increase was in keeping with trends from other 'Heritage' attractions, named the 'staycation' phenomenon. This year in both June and August (normally a low-performing month) our figures were notably up on all previous recorded years. This follows a strategy of more low-risk events and promotions (e.g., Music evenings, Mother's/Father's Day; Teddy Bears Picnic), and raising our local profile through website, free listings, and positive (free) editorial.
>
> In addition, opening days were changed this year to open on more weekdays in June, and only Sundays and Bank Holidays from Easter to June (not Mondays).
>
> We have also noted a significant increase in family ticket sales and take-up of free quiz sheets. School visits have slightly increased on 2009 when we saw a 40 percent increase. We have also attracted several 'new' local schools and aim to increase direct mailings and a free 'Teacher Day' to keep this momentum. We also offer free return tickets for children on all school visits.
>
> Crucially, a team of volunteers support all visitor operations. Training programmes for guides, welcomers and school guides has been introduced and recruitment increased through new volunteer leaflets and word-of-mouth.

LESSONS LEARNED

Overall, the approach at Stansted Park over these past few years has succeeded because all stakeholders were considered and a balanced approach to risk was maintained. Throughout, we openly communicated with our audiences as well as our staff and volunteers, streamlined costs, provided greater access through free admission as able, increased the length of displays to accommodate workflow in the house, and greatly considered feedback from participants, which enabled us to understand which events were successful and which programs were less so.

Open communication occurred over several channels by putting event dates into newsletters, taking on suggestions for themes that were welcoming and edu-taining. For instance, the Portraits program inspired observations from young people of both genders that they were dressed "like Pirates [of the Caribbean]"—a valid yet unexpected connection to eighteenth- century-costumed movies rather than to our portraits. However, this came from visitors' own cultural experience, was valued as rewarding, and provided a route to consideration of similar clothing painted by eighteenth-century artists and our collection of antique fans.

The philosophy of "Keeping It Simple" hastened implementation and reduced costs. Uncomplicated, accessible activities, proven by formal educational experience, were easily augmented with quiz sheets and pictorial and pattern-matching sheets. Each activity focused on history and engaged with site-specific objects. Historical dramas by the theater group the Pantaloons further promoted engagement: "In our theatre, your imagination is just as important as ours."[8]

A strategy of free child entry only gradually evolved, ensuring more adult paid admissions and increasing goodwill and positive publicity. Stakeholders were reluctant to take this risk until it was shown to be increasing income and not adding to costs. Increases in wear-and-tear were not apparent through breakages or losses, but lesser environmental impact might have been measured by dust sampling had scientific resources been available.

Initially Wednesday was nominated for "family days." However, the time taken to set up, risks involved in moving objects, and increasing demand encouraged extension to a week (equal to four House Open days) for each activity. This gradual development lessened risk of failure, allowed "try-outs," and helped inform what to repeat (Portrait Day), drop (Arboretum Walks), or extend (Teddy Bears).

Feedback forms were a comparatively cumbersome measure of outcomes. Now, Facebook and TripAdvisor as well as the Visitor Book and end-of-season figures can assess an activity. A child-friendly website, such as that of Longleat, would increase engagement from the very start of our

potential visitor's relationship, and such virtual visits can be electronically tracked. Social media skills are a vital low-cost resource for spreading news and receiving feedback, ideas, and images from participants in events as they happen.

DRILLING DOWN: WHAT'S NEXT?

Three aspects to heritage sustainability are referred to as the "Triple Bottom Line" or "PPP"—a strategy of engaging *People* in a unique *Place* yields *Profit*. By encompassing A.B.C.D.E. principles, however, small events that favor Personal experience and minimize threat to Place do not produce large Profits. Conversely, enormous numbers of People cause noise and damage that diminish quality of Place. For example, SPF's Christmas Fayre attracted so many visitors that artifacts had to be removed from display, incurring risk by movement and storage. This led to a reduction in scale and the decision to spread the event over three days from two to dilute its impact yet retain its audience (and Profit).

HH admission charges rarely cover real overheads, so small-scale events and openings must be subsidized by endowments, sponsorship, subscriptions, or business income. At SPF this has been generated by property rentals and by trading as a corporate venue, maximizing both a "sense of Place" and Profit by elevating charges for exclusive (personal) use.

Encouraging visits from a young age is a means of "future-proofing" sustainability in engagement and attendance. In a recent campaign the National Trust focused on outdoor family activities that do not impinge on fragile collections or interiors, and many HH have built play areas, on a huge scale at Chatsworth and Wilton, as an alternative to families entering the house. Encouragement of visits comes through membership promotion as pioneered by Blenheim's slogan: "Buy 1 day get 12 months free!" Every event potentially increases this income sector, widens the visiting demographic, and acts as a "gateway."

The "Campaign for Kids in Museums" offers guidance and suggestions for reaching younger audiences, such as setting up a Youth Panel, giving families curatorial input, promoting competitions and [child] "Takeover Days" through workshops, websites and blogs, and connecting to their Manifesto. Registering on free events listings with such national days as the Big Draw and Heritage Open Day gives access to research, advice, trends, and reports. Outcomes indicate new demographics are reached by national media campaigns and social media, while preserving a "local" or "community" ethos.

Over the past decade, some local HH events have grown tremendously from small beginnings. Of particular mention are Goodwood's Festival of

Speed and Revival, which attract £12m ($18.2m) into the local economy.[9] They produce incomes and sponsorships but use the house as backdrop, in contrast to the small scale events at SPF that were centered inside.

A new challenge is the need to respond instantly in the world of social media. Appropriate skills and training are essential for event organization and delivery, and as technology has developed, it has become a low-cost asset in engagement and marketing, while enabling new channels for sharing knowledge. Social media groups and resources that enable exchange of ideas and engagement between professionals and the public are routinely used by younger visitors but should not be regarded as a substitute for engagement. Digitalization and virtual tours may give an interesting and interactive experience but cannot convey the sense of place and atmosphere that distinguishes the HH museum. For instance, at Rodmarton Manor visitors may touch the Arts and Crafts furniture to feel how it was made. At SPF items are used and handled. Soap and lavender bags can be smelled; blankets can be felt; aprons can be worn. As a means of engendering engagement by looking and sharing thoughts, enabling conversation and observations between generations, the family-friendly visit is a vital part of sustainable HH heritage interpretation.

NOTES

1. Lisa White, "The National Trust and its Country Houses," in *Looking Ahead: The Future of the Country House,* Attingham Trust Conference Papers, October 2012, 84–90.

2. "Could This Be the Last Night of the Proms?" The News, Portsmouth, U.K., www.portsmouth.co.uk/what-s-on/could-this-be-the-last-night-of-the-proms-1-1247099.

3. Annual reports at www.visitengland.org.

4. Dea Birkett, "Why I Don't Believe in a Code of Behaviour for Museums," *Telegraph,* April 12, 2014, www.telegraph.co.uk/culture/museums/10687638/Why-I-dont-believe-in-a-code-of-behaviour-for-museums.html.

5. Dan Kraker, "OK to Touch? Glensheen, Home Museums Rethink Rules to Lure Visitors," *Minnesota Public Radio,* August 11, 2014, www.mprnews.org/story/2014/08/11/ok-to-touch-glensheen-home-museums-rethink-rules-to-lure-visitors-.

6. The Anarchist Guide to Historic House Museums Group, www.linkedin.com/groups/Anarchist-Guide-Historic-House-Museums-4770082?home=&gid=4770082&goback=.nmp.

7. Susie Messure, "A Gallery Visit? Leave the Children at Home, Says Top Artist," *The Independent,* August 3, 2014, www.independent.co.uk/arts-entertainment/art/news/a-gallery-visit-leave-the-children-at-home-says-top-artist-9644678.html.

8. The Pantaloons, www.thepantaloons.co.uk. SPF audiences grew from approximately eighty to approximately three hundred in three years.

9. "Economic Impact of the Goodwood Revival on the Surrounding Area." A report published in March 2013 by The Federation of British Historic Vehicle Clubs and the University of Brighton: www.fbhvc.co.uk/_file/78/goodwood-reportfinal-corrected-proof-pdf.

RESOURCES

Websites

The Big Draw: www.thebigdraw.org.uk.

Campaign for Drawing: www.campaignfordrawing.org.

The Campaign for Kids in Museums: kidsinmuseums.org.uk/, with its Manifesto, annual nominated awards, and media partners.

Culture 24: www.Culture24.org.uk.

Culture Disco Tumblr: www.culturedisco.com.

English Heritage: www.english-heritage.org.uk/.

Heritage Open Day "Free to Explore!"; www.heritageopendays.org.uk.

Historic Houses Association (HHA): www.hha.org.uk/.

Museum Next: Europe's Major Conference for the Future of Museums· www.museumnext.com.

Museums at Night: www.culture24.org.uk/places-to-go/museums-at-night.

National Association of Decorative and Fine Art Societies: www.nadfas.org.uk/.

The National Trust (NT): www.nationaltrust.org.uk/.

Royal Oak Foundation: www.royal-oak.org.

Stansted Park: www.stanstedpark.co.uk.

Stansted Park Foundation: opencharities.org/charities/1101251Stansted Park Facebook: www.facebook.com/stansted.park, includes images sent in by families.

Books

Waterfield, Giles, ed. *Opening Doors: Learning in the Historic Environment.* Attingham Trust Report, 2004.

SEVEN

A Natural Solution to Increasing Engagement with Our Local Environment and Museum Collections

Jan Freedman, Plymouth City Museum and Art Gallery, U.K.

As well as being surrounded by a wonderfully diverse variety of beautiful natural environments, the city of Plymouth, England, is over 33 percent luscious green space. From an endless coastline teeming with marine fauna to luscious natural meadows crawling with mini-beasts and packed with wildflowers, Plymouth is one of the greenest cities in the United Kingdom.[1] Coupled with this naturally rich environment are the extensive natural history collections held at Plymouth City Museum and Art Gallery (PCMAG). With a diverse range of collections including beetles, moths and butterflies, herbaria, skeletons, taxidermy, spirit specimens, minerals, and ice age fossils, these collections are a real part of Plymouth's heritage.

PLANNING

One of the key areas where museums have become more active in recent years is engagement. By running events and activities in and out of the building, the museum reaches new audiences who may not have been aware of the collections before.[2] There appears to have been a shift from specimens hidden away behind closed doors, with a focus on getting them out for people to see. Although this appears to be a recent innovation, museum curators were engaging with the public over a hundred years ago, mainly through schools; one curator in 1890 used collections to assist the teachers in their classes;[3] natural history curators at Sheffield Museum developed displays in schools using real specimens.[4] Engagement plays a key role today in promoting the collections and their stories that are locked away in our storerooms and ensuring that the museum is visible to the local people.

71

Prior to 2005, it was apparent that there were no local natural history groups in Plymouth utilizing the rich and diverse environments for people to explore their local area. PCMAG and Plymouth University discussed ideas about developing family-friendly natural history events, with the aims to:

- develop a variety of different natural history events which are open to all;
- link the events to the natural history collections held at the museum where possible;
- ensure an event is organized once a month using the sites in and around the city of Plymouth; and
- build on and develop our partnerships within the city.

A core team was set up with colleagues across departments, including the marketing and development officer, a member of the education team, the natural history curators, and the technician in the School of Biology at Plymouth University. A range of staff with different backgrounds enabled a variety of different ideas for events and activities.

The team wanted this new natural history group to be focused on families, being truly *family friendly*: events and activities that families can enjoy and can participate in together.[5] It was essential to develop a range of different events each month that were hands-on, interactive, and fun, where both the adults and the children could learn together. Key to this was the presence of enthusiastic museum and university staff at each event to engage and inspire the families to ask questions and join in as a family.

Branding was vital for this new group. The team wanted to ensure it stood out and was instantly recognizable across the city.[6] A branded activity is one that is familiar to people, builds its reputation, and differentiates from other similar activities, and we wanted our brand to be just that. The name of this natural history group had to reflect the aims, to be simple and not clever, and to say what we are about. We came upon the short, catchy name *Wild about Plymouth*, which worked perfectly. Working with the museum designers, a simple but visually recognizable logo was developed.[7]

IMPLEMENTATION

Although PCMAG and the university had run successful ad hoc engagement events previously, no formal market research had been carried out to know if there was a demand. The team was aware that running an extensive program could be a gamble, so a pilot program was developed

to test the need for a family-friendly natural history group in Plymouth. Four events spread across 2005 and 2006 were organized, including a spring walk in the woods, peregrine watching in a local nature reserve, a bug hunt, and a boat trip exploring the shoreline, all linking to the museum collections. The promotional material was minimal to limit costs: local radio and newspapers covered the events, and leaflets were given out to museum visitors and schools. Each event proved popular, with over twenty people turning up, demonstrating a genuine desire for people to come along and explore *their* city's nature.

With the success of the pilot events, a program for *Wild about Plymouth* (WaP) was developed in September 2006 and continues today. WaP wanted to offer a large variety of events to ensure it was reaching lots of different people. A huge assortment of biology-, botany-, and geology-themed events have been covered in the programs, including bug hunts, seashore safaris, dawn chorus, moths and bats, winter waders, fungi hunt, woodland walks, dinosaur days, and geology walks. Local beaches, parks, and meadows are all used to run the events in the warmer months. These outdoor venues allow the families to explore environments and discover the wildlife that is quite literally on their doorstep.

During the colder winter months events are held indoors either at the museum, the university, or at off-site partner venues. Here, the events

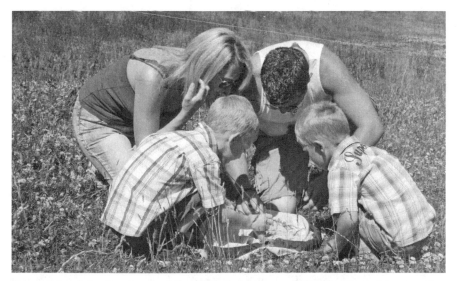

Figure 7.1. A family at one of the Wild about Plymouth bug hunts working together to examine their mini-beast finds. The Wild about Plymouth group are proud to encourage families to work together and learn from each other to explore the natural world around them.

are focused on a theme and use real specimens from PCMAG's collections alongside related craft activities. The indoor events attract a larger number of visitors and provide an opportunity to bring out lots of real museum specimens that are used by staff and volunteers to engage with the visitors.

The group has worked with more than thirty different partners across the city, providing a large range of support and expertise at the events. The partners have benefited by promoting their organization to interested members of the public, and the partnerships have benefited PCMAG by increasing the profile of the museum, raising awareness of the collections, and developing exciting new projects.

In terms of costs, the WaP program was fortunate to receive initial funding from 2006 until 2012 (the budget ceased in 2013).[8] This relatively small budget of £2,500 (around $4,000) was used to print leaflets and purchase resources for the events (nets, buckets, cards, magnifying glasses, and other supplies). The initial outlay for resources was high, but this more than halved in 2011–2012, because a good stock of reusable resources have been purchased. The biggest cost since has been the production of the leaflet.

In 2008, it was decided to charge a small fee for some bookable events to assist with covering costs: £2.50 ($3.91) for adults, £1 ($1.56) for children, and children under five go free. This later proved successful in generating enough income to cover the printing of the leaflets and importantly proving that the program could be self-sustainable. The income generated has ensured that the overall expenditure for WaP has decreased with time (see table 7.1). The total expenditure for 2013–2014 was just £23.39 ($36.59) due to reduced publicity costs, a strong stock of resources, and the ticketed events with a small charge.

RESULTS

Evaluation questionnaires provided the opportunity for the attendees to feed back their individual experience of the event, highlighting areas that could be improved upon.[9] Evaluation was carried out at each event, cumulating in an annual evaluation report.[10] The questions are the same for each event, allowing clear information to be extracted (the final question was different for each event, and was specific for partners). To encourage attendees to fill out the evaluation, the questions allow one-word answers or more detail if desired. Each question is written to fit with the generic learning outcomes (GLOs) as a mechanism for measuring written feedback.[11] The questions provided an excellent spread of feedback demonstrating the success of the program, as well as highlighting important areas for development.

Table 7.1. Total expenditure (costs minus income) for developing the *Wild about Plymouth* program since 2006. An initial setup budget was required for publicity materials and resources. Over the years as the program has become more efficient at saving money, and generating income, the total expenditure has been drastically reduced, becoming almost self-sustainable.

Financial Year	Publicity	Resources and Events	Income	Total Expenditure
2006–2007	£1,498.55 ($2,343.55)	£586.74 ($917.73)	n/a	£2,085.29 ($3,261.64)
2007–2008	£1,370 ($2,142.94)	£286.19 ($477.66)	n/a	£1,656.19 ($2,590.60)
2008–2009	£795 ($1,243.59)	£457.23 ($715.23)	£189 ($295.67)	£1,063.23 ($1,663.30)
2009–2010	£530 ($829.12)	£471.92 ($738.23)	£255 ($398.90)	£746.92 ($1,168.33)
2010–2011	£992 ($1,551.79)	£650 ($1,016.70)	£247.15 ($386.58)	£1,395 ($2,182.06)
2011–2012	£473 ($739.91)	£372.03 ($582)	£217.50 ($340.29)	£627.53 ($981.80)
2012–2013	£488 ($763.51)	0	£359 ($561.68)	£129 ($201.83)
2013–2014	£375 ($586.64)	£73.39 ($114.81)	£425.50 ($665.64)	£23.39 ($36.59)

The selection of comments from the annual evaluations shows new knowledge learned from these events. The WaP program includes an enormous range of events, from bug hunting to stargazing, attempting to accommodate all curious minds and increase repeat visits. The questionnaires also highlighted individuals' preferences for information; there were several different answers for the same question at one event, illustrating that each individual will take away something different.

Perhaps the most wonderful feedback from more people since 2012 has been a really strong focus on "family involvement" and "working together," suggesting a shift in people's attitudes toward wanting to get outside and enjoy the outdoors together. Approachable, enthusiastic, and engaging "experts" proved to be very successful with the attendees linking museum specimens to the environment around them.

LESSONS LEARNED

Through the years, the annual evaluation reports have picked up areas for improvement. The programs for 2006–2007 and 2007–2008 had several

events that were bookable due to limited space, but although people had booked, many failed to attend. To ensure attendees showed up at the events they had booked, we introduced a small charge for the tickets. This has proved successful, with only one or two people failing to turn up. It has also been extremely useful to demonstrate that the program can be self-sustaining by generating a small amount of income to help cover costs.

Working with external partners links the museum with new organizations in the city, halves the planning, and ensures a diverse range of events and activities. However, there have been occasions when external partners have canceled, or changed the location details, of an event on very short notice. As WaP is marketed through PCMAG and is a museum-branded event, we have had to notify people who are booked on these canceled events, update information on relevant websites and social media, and deal directly with any complaints.

For some events it has proved difficult to describe the meeting place, as they have been held at meadows or woods, where very early on a small number of people did turn up at the wrong location. To ensure this doesn't happen, staff visit the site beforehand and provide the exact, detailed meeting point. An annotated map for each event is produced for the museum front-of-house staff as assistance for inquiries.

The annual evaluation has proved vital to continually improving the program and events. Feedback from specific events is addressed, and the evaluation highlights common areas which can be improved upon. Without consistent evaluation throughout the program, WaP would not be able to improve.

DRILLING DOWN: WHAT'S NEXT?

The program of WaP events has proved very successful. Since the initial launch of these events, the number of attendees has more than doubled: from 783 in 2006–2007 to a huge 1,964 attendees in 2013–2014. The variety of marketing mechanisms through leaflets, local radio, newspapers and magazines, and social media has proved more than successful. When asked "How did you hear about the event?" over a quarter responded "word of mouth," indicating that the brand has become well established.

The evaluation has provided important information about the age ranges of the attendees. Each year the pattern is fairly similar, with the highest number of attendees between zero and ten years old; between thirty-one and forty; and between forty-one and fifty. This clearly demon-

strates that the WaP program is hitting the right target audience, with the majority of the attendees being family groups.

The questionnaires also allowed for the attendees to leave their post codes, which can be mapped to illustrate where the attendees are coming from. Small numbers do travel into the city from smaller towns just outside the city, but the majority of the attendees are from Plymouth. A map of the post codes indicated areas in the city where WaP is not reaching: this information is being used to target these areas with additional marketing and to plan future events.

The annual total expenditure along with the total number of attendees enables the cost-to-visitor ratio to be calculated. At the initial launch of WaP the cost-to-visitor ratio for the 2006–2007 program was high at £5.73 per person ($8.96). This has been significantly reduced for the 2013–2014 program to £0.83 per visitor (around $1.30) (see table 7.2). A budget at the program's infancy allowed resources to be purchased and a good stock to be built up, which is still being used today. Along with not purchasing new resources, costs have been reduced in other ways: for example, producing a smaller run on the printed leaflets, as the evaluation demonstrated that other, free, marketing methods have been successful.

WaP has kept to a simple formula to deliver its programming and events, which has proven to work successfully:

Table 7.2. The cost-to-visitor ratio, calculated by the expenditure plus staff time, divided by the total number of attendees. (The staff time is a rough estimate based on hours of involvement, including meetings, planning, and delivering the sessions.)

Financial Year	Total Attendees	Total Expenditure	Staff Time	Cost per Visitor
2006–2007	783	£2,085.29 ($3,261.64)	£2,400 (3,754.82)	£5.73 ($8.96)
2007–2008	863	£1,656.19 ($2,590.60)	£2,400 (3,754.82)	£4.7 ($7.35)
2008–2009	972	£1,063.23 ($1,663.30)	£2,400 (3,754.82)	£3.56 ($5.57)
2009–2010	1,487	£746.92 ($1,168.33)	£2,400 (3,754.82)	£2.11 ($3.11)
2010–2011	1,385	£1,395 ($2,182.06)	£2,400 (3,754.82)	£2.74 ($4.29)
2011–2012	1,812	£627.53 ($981.80)	£2,400 (3,754.82)	£1.67 ($2.61)
2012–2013	2,310	£129 ($201.83)	£2,400 (3,754.82)	£1.09 ($1.70)
2013–2014	1,964	£23.39 ($36.59)	£2,400 (3,754.82)	£0.83 ($1.30)

- Each event is organized by one member of the team, limiting miscommunication and wrong information.
- Where possible, we seek external partners in the city to assist with hosting and running the events. This worked well at sharing the organizing and in the event risk assessments.
- Staff at PCMAG and Plymouth University are present at each event, supported by staff from partner organizations and volunteers. These were "expert scientists," and the attendees felt very comfortable asking questions.
- Events regularly use real specimens from the museum collections, including pinned insects, taxidermy, spirit-preserved specimens, rocks, and fossils. As well as learning something by participating in activities and speaking to real scientists, the attendees enjoyed seeing *real* specimens.
- Each event was kept simple. Simple activities were developed where the attendees were discovering for themselves (for example, at the annual bug hunt, the families take some nets and tubs, scurry in the undergrowth, and the "experts" go around to help identify the insects).
- Evaluation was undertaken at each event. This has proved essential in improving events to meet the needs of the attendees. The annual evaluation reports are also important to prove the success of the program that supports its ongoing delivery.

The WaP idea has been a success, with 1,964 people attending the last program of events. The range and the different locations of the events make sure that there are regularly new things to see and do. WaP prides itself on running a program that is family friendly and delivered by approachable and knowledgeable members of staff. The feedback has shown that the families have enjoyed time discovering something new together, and they have enjoyed the friendly and enthusiastic members of staff. Using museum and university staff, along with real specimens from the collections in and around the city, has given the people of Plymouth a new reason to be passionate about their environment.

ACKNOWLEDGMENTS

Wild about Plymouth was developed by my previous boss, Helen Fothergill; she put in all the hard work to get this successful group off the ground. I would like to thank all the staff at PCMAG who have helped make *Wild about Plymouth* such a success, in particular, Jo Clarke, Ed Delicata, and Jill Downing. Our support from Plymouth University, Peter Smithers,

has championed the group from the very beginning and provided a lot of excellent ideas and expertise. I would also like to thank the numerous partners, and wonderful volunteers, who have supported the events across the city. And a final thank you to all those wonderful families who have joined in on rock pooling or bug hunting, where their enthusiasm for discovering something new never faded no matter what the weather!

NOTES

1. See Jan Freedman, Helen Fothergill, and Peter Smithers, "Wild about Plymouth: The Family Friendly Natural History Group in Plymouth," *NatSCA News*, Issue 19: 2010, 30–37.

2. See Hazel Moffat and Vicky Woollord, eds., *Museum & Gallery Education. A Manual for Good Practice,* London: The Stationary Office, 1999, 178–79.

3. See Henry Higgins, "Appendix A. Circulating Museum for Schools and Other Educational purposes," in H. M. Palmer and E. Howarth, eds., *Museums Association Reports of Proceedings with the Papers Read at the First Annual Meeting. Held in Liverpool. June 17–19.* Published by the association, 1890.

4. Elija Howarth, "The School Museum System in Sheffield," *Museums Journal* 7 (10) 1908: 339–43.

5. Hagi Allon, "Working with Children and Young People," in *Museum and Gallery Education: A Manual of Good Practice*, edited by Hazel Moffat and Vicky Woollard, London: The Stationary Office, 1999, 82.

6. Sue Runyard and Ylva French, *Marketing & Public Relations Handbook for Museums, Galleries & Heritage Attractions,* London: The Stationary Office, 1999, 159–60.

7. The *Wild about Plymouth* logo, with the most up-to-date list of events, and free leaflet to download can be viewed here: www.plymouth.gov.uk/museum-wildaboutplymouth.

8. *Wild about Plymouth* was fortunate to receive funding from *Renaissance in the Regions*. This was a British government initiative in 2001 that provided additional funding to regional museums to assist with supporting costs for staff, programs, and improving services. The funding ceased in 2012 due to the abolishment of the Museums, Libraries and Archives Council (MLA), who were in charge of advising on the funding. The responsibility, along with a cut budget, was passed to the Arts Council. With several cuts happening, it was decided to assess whether the *Wild about Plymouth* events could be more self-sustainable. (For more information on Renaissance in the Regions, see here: www.museumsassociation.org/download?id=12190.)

9. *Museum and Gallery Education: A Manual of Good Practice*, edited by Hazel Moffat and Vicky Woollard, London: The Stationary Office, 1999, 177.

10. The evaluation reports for *Wild about Plymouth* are held at Plymouth City Museum and Art Gallery and are available on request for viewing. Please contact the author for a PDF.

11. Inspiring Learning for All, Museums, Libraries and Archives, www.inspiringlearningforall.gov.uk. The framework is built around how people engage and learn and the outcomes of the learning. As a measurement, museums can assess questions against five generic learning outcomes (GLOs): Knowledge and Understanding (learning new facts, making sense, and having a deeper understanding); Skills (knowing and being able to do new things, physical, social, and intellectual skills); Attitudes and Values (feelings, opinions, perceptions, and capacity for tolerance); Enjoyment, Inspiration, and Creativity (having fun, showing creativeness, and being inspired); Activity, Behavior, and Progression (what we have done, will do and do do, and a change in how we look at our lives). Questions can be written so that the answers will provide information on the GLOs, so evaluators can use this framework for reporting feedback.

RESOURCES

Freedman, Jan, Helen Fothergill, and Peter Smithers. "Wild about Plymouth: The Family Friendly Natural History Group in Plymouth." *NatSCA News*. Issue 19: 2010, 30–37.

Freedman, Jan, et al. "Taxing Taxonomy, Scary Systematics and Confusing Classification: Interactive Activities to Make Scientific Jargon More Accessible." In Anastasia Filippoupoliti, ed., *Science Exhibitions: Communication and Evaluation*. Museums Etc. 2010.

Higgins, Henry. "Appendix A. Circulating Museum for Schools and Other Educational Purposes." In H. M. Palmer and Elija Howarth, eds. *Museums Association Reports of Proceedings with the Papers Read at the First Annual Meeting. Held in Liverpool. June 17–19*. Published by the association. 1890.

Howarth, Elija. "The School Museum System in Sheffield." *Museums Journal* 7 (10): 1908, 339–43.

Moffat, Hazel, and Vicky Woollard, eds. *Museum and Gallery Education: A Manual of Good Practice*. London: The Stationary Office, 1999.

Runyard, Sue, and Ylva French. *Marketing and Public Relations Handbook for Museums, Galleries and Heritage Attractions*. London: The Stationary Office, 1999.

EIGHT

Closing the Fossil Hall and Opening Fotorama!

Online and Onsite Engagement at the National Museum of Natural History

Charles Chen, Jennifer L. Lindsay,
Siobhan Starrs, and Barbara W. Stauffer,
National Museum of Natural History

On April 26–27, 2014, the National Museum of Natural History planned a final weekend of special events to mark the closing of the National Fossil Hall and beginning of a projected five-year renovation. The festivities included opportunities for visitors to interact with scientists, view and handle objects from the museum's teaching collection, and celebrate the Fossil Hall while building excitement for the new exhibition. Fotorama! was designed as a low-budget, one-time event to facilitate spontaneous interactions between visitors, museum staff, and the fossil collection, yet its successes have subsequently triggered curiosity about how to create new projects and programs using a similar nexus of online and onsite activities.

PLANNING

The National Museum of Natural History (NMNH) hosts 8 million visitors per year—an average of more than twenty thousand visitors per day. Despite such robust visitor numbers, the NMNH, like museums of all sizes, is exploring alternative ways to reach a wider online audience and to enhance the experiences of onsite visitors. Recent programs have focused on increasing opportunities for informal learning by providing hands-on access to objects, as in the museum's newly opened Q?rius and Q?rius Junior learning centers, and by integrating arts-based and interdisciplinary programs that recognize and value different approaches to learning in science-based disciplines. With the closure of its popular fossil exhibit, the museum's physical space to show fossils has become more limited, but the institution remains eager to continue to share its ongoing research and collection with visitors during the renovation, in person

Figure 8.1. Visitors enjoy Fossil Hall Fotorama!, April 2014. Photograph by Donald E. Hurlbert.

and online. Fossil Hall Fotorama! explored the potential for using social media as a way to connect visitors to visitor- and community-centered programs that facilitate lively, spontaneous interactions between visitors of all ages, the museum's scientists and staff, and the collection, whether online or onsite.

The museum had never attempted anything quite like Fossil Hall Fotorama! before, but there were several related institutional precedents. First, the museum had previously developed a multifaceted online/onsite outreach strategy that generated a high level of public and staff participation to build a large-scale, collaborative, community-created display called the Smithsonian Community Reef, a "satellite" of the Institute for Figuring's Crochet Coral Reef, on view in the museum's Sant Ocean Hall in 2010. This outreach effort successfully shared the exhibition's substantive content and the museum's collections with a local and national audience. Within the NMNH, this project inspired curiosity about whether future projects and programs hosted or created by the museum could be enhanced by a similar nexus of online and onsite activities specifically tailored to their needs. Fotorama! provided the context within which to revisit or reuse this integrated approach.

Second, one of the challenges faced in 2010 was that the museum could not fully capture or sustain the audience gained for the community proj-

ect using museum-branded social media outlets. By 2014, the museum had multiple, robust social media outlets including the "Deep Time at the Smithsonian" Facebook page for fossil enthusiasts, a paleontology-focused blog, and a regular fossil-focused Twitter feed. The museum was also creating a new National Fossil Hall microsite on the museum's web page to centralize access to all the paleo-based online resources. All these outlets combined to share news about ongoing fossil research at the museum and candid, behind-the-scenes images and updates on the renovation-in-progress. These aggregated online resources provided a branded, content-rich platform that could readily be used to host Fotorama! and potentially to retain any new audiences that it developed. In addition, at the same time that Fotorama! was under development, the museum was engaged in a comprehensive social media campaign to welcome a *T. rex* owned by the United States Army Corps of Engineers as a centerpiece of the future Fossil Hall. The Fotorama! team was able to collaborate with the *T. rex* promotion to increase the audience for fossil-related activities, both online and onsite.

IMPLEMENTATION

The goal of Fotorama! was to invite visitors to join the museum in celebrating an important moment in its institutional history that would capitalize upon the already-existing practice of visitors taking photos and selfies in the exhibit on a daily basis. Through social media, visitors could share these photos via a dedicated online gallery. To connect the online photo sharing to the onsite events planned for the closing weekend, a "Red Carpet Photo Opportunity" offered visitors the opportunity to dress as paleontologists and have their portraits taken "with the fossils and fun props." The portraits, along with the selfies and candid photos shared by visitors and staff in the weeks preceding the closing weekend, would be displayed on a large monitor in the hall and then hosted in an online gallery.

The program evolved in three sequential phases that required extensive cross-departmental support. Phase 1 established branding and online channels; Phase 2 addressed privacy and technical issues; and Phase 3 comprised the planning, setup, and coordination of the onsite activity. Phases 1 and 2 drew most heavily on the expertise and support of staff from Education and Outreach, Exhibits, Press Office, Online Advancement, and Development who had pertinent experience in social media, web design, and online visitor engagement. Staff and volunteers from Education and Outreach, and from Visitor Services, Imaging, and Online Advancement, supported Phase 3—the onsite activity, consisting of the

Timeline

Staff from the National Museum of Natural History's offices of Education and Outreach, Exhibits, Press Office (Social Media), Online Advancement, and Development worked with an outside contractor to create and implement Fossil Hall Fotorama! in ten weeks. The budget was $5,000, not including overhead. The project timeline below outlines the key steps along the way, although replicating a project such as this would necessitate adaptation to one's own workflow and protocols.

2/24/2014
Scoping Meeting

3/7/2014
Budget/Plan Approved

3/10/2014
Contractor on Board/Project Development Initiated

3/14/2014
Final Plan Approved

3/28/2014
Soft Launch (Online Component)

4/3/2014
General Counsel Approval

4/4/2014
Public Launch
(Online Component)

4/26–27/2014
Public Program
(Onsite, In-Person Component)

05/01/2014
"Thank You" Letter to Participants with Fotorama! Photo Gallery Link
(Closing Submissions)

Red Carpet Photo Opportunity, and the post-event follow-up with participants. Twenty-one volunteers supported the onsite activity, working in shifts with the contractor to assist visitors to complete photo release forms, select and don costumes and props, and queue for the photographers.

During Phase 1, the team coined a quirky and retro-sounding name for the program that fit with the informal tone of the ongoing *T. rex* social media campaign and maximized synergies between these two activities by cross-posting to the same online channels. The team developed lively, eye-catching graphics to give Fossil Hall Fotorama! a recognizable look online and in the museum. To attract the widest possible participation across age groups and among onsite visitors, e-mail subscribers, and online followers, Fotorama! included a broad range of image types, including archival images from the museum's collection, selfies, vintage vacation photos, and artsy fossil shots. To extend photo sharing beyond Facebook members, the museum created a general submission page on the new National Fossil Hall microsite. The museum used Wufoo, an online form builder, to collect photo submissions. A mandatory release form embedded in the submission form allowed the museum to secure unrestricted use of all photos submitted. All photos were reviewed to ensure appropriate content prior to posting. After the team seeded the Facebook gallery with archival photos and offbeat staff selfies, "likes" to Deep Time began to increase and online photo submissions from visitors and staff began to trickle in.

During Phase 2, the team addressed a number of institutional challenges to the spontaneity that using social media as a basis for a visitor-centered program was intended to provide. First, the Smithsonian has rigorous policies in place to protect the privacy of all visitors, and of minors in particular, and there were changes to this policy in the weeks just preceding Fotorama! As a result, online submissions were restricted to adults only. While the museum received wonderful photos of all types via online submissions, these were more limited in number than expected with a yield of just over seventy photos from fifty submitters.

Phase 3, the onsite photo booth on the closing weekend, offered an opportunity to be photographed in the gallery with the fossils; however, the smooth delivery of visitor access to the photos was hampered in two ways. First, follow-up communication between visitors and the project team was fractured when the e-mail addresses requested from visitors on the photo release forms were not provided or were otherwise unusable. Second, once the photographs were deposited online, there was no clear way for visitors to locate their photos quickly on their own. In thinking about ways to streamline the next iteration of this project, such obstacles could be overcome by automating the photo permission process using

tablets or other portable devices tethered to a mobile workstation that could capture more accurate data to associate with the photos in an effort to share the photos and links immediately and seamlessly with participants via e mail.

Nonetheless, public participation in the onsite photo booth far outstripped online submissions. The photo booth setup in the Fossil Hall was attractive and fun, and the onsite experience also offered an immediate, relaxed, and lighthearted opportunity for visitors to engage with each other and with the museum's two photographers, who also managed to keep the lines moving! The photographers took more than 350 memorable portraits that included nearly 800 individuals. Many visitors were inspired to have their portraits taken simply by watching the professional photographers at work, and seeing the animated group photos display instantly on the monitor in the museum. A look at the Red Carpet portraits in the Fotorama! gallery on Facebook shows the onsite activity appealed to people of all ages, and that both children and adults felt free to combine the theatrical, paleo-inspired costumes and props provided in highly creative, playful ways.

Together, Fotorama!'s online opportunities and onsite events allowed visitors and staff to participate in the celebration of the dinosaur hall while building excitement for the National Fossil Hall of the future.

RESULTS

Fossil Hall Fotorama! was entirely new, experimental, and event-specific. The Fotorama! team hoped to engage as many visitors, supporters, and staff as possible to join the museum in marking an important milestone in its institutional history within the limited timeframe. There was no basis upon which to predict how visitors would respond to the invitation to share their personal photos online. No formal assessment of the project was planned in advance. The number of participants was small—about 850 staff, visitors, and subscribers. About one-third of Fotorama!'s participants onsite were new to the museum's online advancement officer. After the event, the Fotorama! photo gallery (via Deep Time at the Smithsonian on Facebook) revealed a 30 percent increase in "likes," with spikes in "likes" easily correlated to posts by Fotorama! and the concurrent *T. rex* media promotion. Comments provided by visitors on Fotorama! were uniformly positive. Within a month of the event the photos in the Fotorama! album had been viewed more than eleven thousand times.

To better understand the visitors' reactions to Fotorama!—its successes or failures and their interests in follow-on programs—an e-mail or other form of electronic survey could have been implemented (which would

require additional planning and staff time to develop and analyze). In a museum where numbers of visitors are so large—an average of twenty thousand visitors per day—it would be possible to overlook Fotorama!'s very modest success. Instead, the museum has showcased its success through the use of Fotorama! photos elsewhere online, in the museum, and on several of the museum's paleontology-focused web pages. Further, the museum has offered a similar photo booth activity in the Butterfly Pavilion. But most important, as a result of Fossil Hall Fotorama!, and other experimental public engagement projects, past and current, staff have begun to question whether large numbers of participants should be considered the defining characteristic of a successful program. When the Internet provides individuals an unprecedented opportunity to customize their experiences of the world, serving the passionate interests of many smaller groups can be an alternative and equally valid measure of success. With increased numbers of crowdsourced and citizen science–based projects flourishing on the Internet, and with a collection that spans the natural world and encompasses millions of objects and billions of years of history, only a fraction of which can be exhibited at any one time, Fotorama!'s model of interrelated online and onsite programming provides almost limitless possibilities for an institution like the National Museum of Natural History. One area of future inquiry would be to test whether online/onsite programs are more successful when focused or targeted on the interests of smaller groups.

LESSONS LEARNED

Giving the public adequate notice of the project in the short time available was difficult because of the lack of lead time in general, and because staff time to advertise the project via e-mail, Twitter, and other online outlets was limited by other competing commitments. Further, signs advertising the project were not widely displayed in the National Fossil Hall itself until very late in the project out of a concern that advertising of any kind in the exhibits is distracting to visitors and undermines the quality of the visitor experience. Signage was placed outside a café in the exhibit area, and at the entrance and exit to the exhibit, but the museum was reluctant to advertise the project by placing signs inside the exhibit where they may have been more effective at promoting the spontaneous public engagement via social media that the project was designed to facilitate. This dilemma highlights the challenges inherent in testing out new ways to connect with visitors while preserving essential features of the visitor experience that the museum values. If keeping the exhibit halls signage-free is of paramount importance, with additional time to plan, a program like

Fotorama! can be more aggressively advertised in other ways. However, no new and experimental program will ever anticipate every potential conflict or challenge that will or could arise.

To develop future participatory projects that focus on a nexus of social media and in-person public programs and to develop a robust audience for a program like Fossil Hall Fotorama!, the museum cannot rely on the passive availability of websites alone; instead, a thoughtful and coordinated effort should include online marketing on the website, social media resources, and e-mail. Online submissions to Fotorama! jumped by 50 percent and included international submissions as a result of just one e-mail to the museum's e-mail subscribers. Moreover, these online activities must be supplemented by in-museum signage where appropriate, and in-person activities.

DRILLING DOWN: WHAT'S NEXT?

Creative, experimental programs like Fossil Hall Fotorama! do not have blueprints. Rather than attempting to prove or disprove the success of experimental programs as stand-alone endeavors, the institution might focus on what worked or did not work in the overall architecture of innovation, as perfecting this architecture may yield a useful and repeatable result of a project like Fotorama! This architecture must be built on a foundation of cross-departmental collaboration and anticipate the creation of tailor-made content and activities. The balance of interests represented in the staff supporting Fotorama! covered most of the museum's important functions, with the exception of curatorial input, which would be essential for a more substantive program. Each team member contributed his or her expertise and creativity to the germination, the implementation, and the critique of Fotorama!

To minimize the extra burdens that developing experimental programs like Fotorama! place on staff and to maximize the motivation to test new ideas, the museum must commit itself to "training in" a more rapid response time, building and rewarding a culture of agility and innovation despite the challenges that large institutions face, nurturing interdepartmental networks and collegial relationships, and fostering the trust and "esprit de corps" that make it possible for the museum's staff to be creative whenever the opportunity arises to do so. Experimental projects can then serve to push the museum and its staff to grow and develop in response to the evolution of technology, to changes in audience over time, and to increased knowledge about ways to prolong visitor engagement with the museum's collection and programs.

RESOURCES

Konigsberg, Jessica. Museums with Impact. "Permission to Play." November 6, 2014. museumswithimpact.wordpress.com/2014/11/06/permission-to-play/

Smithsonian National Museum of Natural History. "Deep Time at the Smithsonian." Accessed November 13, 2014. www.facebook.com/deeptime.smithsonian

Smithsonian National Museum of Natural History. "Fossil Hall Fotorama!" (via Deep Time). Accessed November 13, 2014. www.facebook.com/media/set/?set=a.272667022902108.1073741832.137359743099504&type=1

Smithsonian National Museum of Natural History. "The Hyperbolic Crochet Coral Reef." Accessed November 13, 2014. www.mnh.si.edu/exhibits/hreef/

The Institute for Figuring. "Exhibitions: Sant Ocean Hall, Smithsonian, Washington, D.C." Accessed November 13, 2014. crochetcoralreef.org/exhibitions/smithsonian.php

Smithsonian National Museum of Natural History. "The National Fossil Hall." naturalhistory.si.edu/fossil-hall/

Smithsonian National Museum of Natural History. "Digging the Fossil Record: Paleobiology at the Smithsonian." Accessed November 13, 2014. nmnh.typepad.com/smithsonian_fossils/fossil-exhibits/

Stevenson, Laura, Elisa Callow, and Emiko Ono. *Interplay: Inspiring Wonder, Discovery, and Learning through Interdisciplinary Museum-Community Partnerships.* Los Angeles: The Natural History Museum of Los Angeles County, 2007.

Weil, Stephen E. "John Cotton Dana's New Museum." *Making Museums Matter.* Washington, D.C.: Smithsonian Institution, 2002, 188–92.

Weil, Stephen E. "Museums: Can and Do They Make a Difference?" *Making Museums Matter.* Washington, D.C.: Smithsonian Institution, 2002, 55–74.

NINE

The BioLounge at the University of Colorado Museum of Natural History

J. Patrick Kociolek, University
of Colorado Museum of Natural History

The BioLounge is an exhibition and programming space at the University of Colorado Museum of Natural History. It was started as an experiment, specifically designed to attract an audience sometimes underserved by university-based museums, namely the student body, faculty, and staff of the university. This paper describes how the museum identified the challenges of serving a college-age audience, the planning and approach taken to develop a new kind of exhibition and programming environment, the outcomes of that work, and future developments for the space.

University museums have special callings, as they attempt to interest and attract a campus audience, as well as the broader community in which they reside (Krishtalka and Humphrey 2000; Shapiro et al. 2012). Challenges may exist in the development of exhibitions that fit into campus curricula and the interests and learning styles of eighteen- to twenty-two-year-olds, versus off-campus audience segments, which may include a wide range of lifelong learners, formal K-12 education groups, and families. While eighteen- to twenty-two-year-olds are a group of potential museumgoers that is, literally, right next door, they have been identified as lucrative for a wide range of reasons. And they are not always the easiest to attract to museums (Brunecky 2010).

The University of Colorado (CU) Museum of Natural History resides in four buildings on the CU Boulder campus. It holds over 4.5 million objects; has nine curators who also hold faculty appointments in three academic departments (Ecology and Evolutionary Biology, Anthropology, and Geological Sciences); and maintains five public galleries with approximately fifteen thousand total square feet of public space. There is no admission fee to the museum. Three of the galleries have been focused on content areas related to the tenure homes of the faculty and support the museum intellectually. The Hall of Biology was, for the forty-five years up

to 2008, a gallery of mounted bird and mammal specimens, accompanied by several displays of plastic replica fungi. The gallery exhibits rarely changed over this time. Attendance to the hall was minimal in general, with rare visits from CU students. In fact, CU students were rare in their attendance to the museum generally. In the five years prior to the opening of the BioLounge (2003–2008), student attendance averaged two thousand per year, which was 10 percent of the total twenty-one thousand visitors per year over this time period. Thus, programs focused on getting this audience group to the museum were designed to entice them with the prospects of free food, through a program called "Yes, There Is a Free Lunch After All," where a portion of a submarine sandwich, an individual bag of potato chips, and a cold drink were offered to students to attend lectures at the noon hour.

For a variety of reasons, the museum had recognized the need to update the 2,200-square-foot Biology Hall as well as increase campus attendance. A planning grant was secured from the National Science Foundation to create a hall-wide exhibition on evolution and biodiversity, though implementation funds were never awarded.

In 2008, we began to review audience numbers and sought ways to achieve more of an impact at the museum. Challenges facing campus museums were not ours alone. Around this time, several stories in the press across the United States noted such issues and asked the relevance of museums to the primary missions of certain campuses (Shapiro et al. 2012; Glesne). The staff of the CU Museum asked ourselves how we might boost attendance by CU students. We also wanted the students to utilize the resources of the museum and to appreciate the extensive collections of the museum.

We were also looking for something that would be a "pushback" against traditional exhibitions. Most invite you in, ask you to learn the story of the exhibitions and its pieces (as a unit that hangs together rather than having changing elements), whether on prescribed or multiple access paths, and then to rest for conversation and discussion with perhaps a purchase of a beverage or lunch outside the gallery.

PLANNING

As a preliminary—though important—change, we held discussions in the museum about the possibility of changing the name of the Biology Hall to the BioLounge. Conversations focusing on this topic were extensive, with several presentations until there was a consensus to move forward. The entire museum was invited to bring ideas forward. Inspiration and materials came from every section of the museum, and materials were found

in the collections, curators' offices, and departmental "to be discarded" piles. We decided on a design that would invoke the Victorian era through selected antiques (bought through antique dealers at attractive prices through negotiations during an economic downturn). The look and feel of the space would be very different from the uniform, institutional paint job that the gallery had previously.

The plan was for vitrine elements to be changed, so that the place would have the feel of change, whether a visitor was there two to three times a semester or two to three times a week. Vintage 1950s chrome kitchen tables and chairs, alongside free coffee and tea, would also be added to the more formal couches and chairs. The space also had wireless Internet access. Visitors would be invited to sit down, have a beverage, chat with friends, or check their e-mail/social media interactions. Then they might look at the exhibitions. There is no overall "story" or message put forth in the exhibits. In fact, the ways visitors approached and interacted with the objects and displays allowed them to make their own meaning. In some ways, this would be an anti-exhibition.

IMPLEMENTATION

Once we decided to move forward with the project, six months was given to de-install the Biology Hall and to acquire objects, stories, books, old microscopes, models, ephemera, and furniture. A name and logo were developed and designed in less than a month. A color scheme and design for the room were decided upon, and after the vertebrate zoology specimens were returned to the collections, the space was painted, furniture was installed (including glass cabinets mimicking cabinets of curiosity), and vitrines with collections were installed into the space. A banner was designed and placed at the nearby University Memorial Union (this would be the only advertising we would do for the BioLounge, exclusive of programming). This first iteration of the BioLounge would be relatively modest in terms of cost: about $18 per square foot, including the extra help and materials required to de-install the old Biology Hall, bringing the total cost to around $40,000. It was an effort from across the museum, with every section of the museum (even non-biology sections) contributing content, objects, and ideas.

RESULTS

The hall opened to little fanfare in late 2008. An initial evaluation of the space in 2009 was conducted by Wells Resources, Inc. Museum staff

members were heartened by what they heard. The space was attractive—people loved the space, they loved the coffee and tea, and 85 percent of visitors explored the exhibitions by their second visit. Students were by far the largest audience segment visiting the space, but early morning weekend days did see families with children in the BioLounge. Thus, we adapted to serve hot chocolate in the space during those times. In fact, counter to our interests, survey respondents worried about keeping the BioLounge a secret, so that it did not become too crowded. In the first two years of being open, however, the average number of CU student visits jumped from the preceding three-year average of 2,674 to 8,603 per year in 2009, and overall attendance to the museum jumped as well, from an average over the previous three years of 22,435 to 31,606 in 2009.

In addition to the students who found the BioLounge via word of mouth (by far the most impactful source of information about the place), museum staff started to notice that faculty and teaching assistants would hold office hours and recitations there. Graduate students began to approach the museum, wanting to offer programs in the space, such as "Save the Frogs" and a graduate student–organized symposium on evolution and species concepts. For a museum professional, it is heartening to have visitors want to offer their programs in the museum. A fortuitous stray photographer for the *Daily Camera*, Boulder's local newspaper, wandered in and did a photo exposé of the BioLounge, with images in the local paper and paper's website (www.dailycamera.com/ci_12955408). This unpaid exposure helped create interest in the space outside the CU campus community.

The museum was approached by many outside potential collaborators to use the BioLounge in a number of ways. For example, the museum was a site for the Boulder Fringe Festival in 2012 and during that event worked with EcoArts, a local nonprofit connecting environmental scientists and artists. With the help of community funders, and working with EcoArts, three artists from outside Boulder exhibited works in the BioLounge.

Designers for a renovation of student spaces from Norlin Library came to look at the BioLounge for ideas and inspiration—a nice recognition of our success. While the design ethic and aesthetic is quite different in the widely successful library space where coffee and food are available for purchase, and there is an emphasis on the ability to arrange/rearrange spaces to accommodate student needs, many elements shared between the library and BioLounge are evident. The museum was approached by the Leeds School of Business to open an "incubator" within the Bio-Lounge, to be paid for by the business school. Nonalignment of mission between the incubator (for "business students only") and the museum led to abandonment of this potential collaboration. Because it was driven by business school students, however, the suggestion was a strong indication

to business school staff that a BioLounge-style environment meets student needs. The BioLounge, with its unique décor and almost non-museum look and feel, turned out to be an interesting place to have after-hours events, and rental in the space became more common.

By 2012, annual attendance to the museum by CU students had reached 15,710; the museum attendance by all ages had reached 41,849 annually to the Henderson Building. CU students were approximately 30 percent of the total audience mix, versus less than 10 percent before the BioLounge was opened. The success of the BioLounge was evidenced not only in numbers, but also at times like graduation, when students would bring family members to see the place where they spent many hours of their time during the school year. Formal interviews and casual conversations with visitors indicated a high degree of satisfaction, even during mid-terms and finals, when every seat in the gallery was occupied and most of the wall space had people sitting on the floor propped up against it.

Change in the BioLounge kept apace, but rotation schedules were not maintained, with more "wholesale" change happening during summers or university holidays. Fewer new ideas and content were being contributed by staff to keep the BioLounge fresh. Exhibitions were becoming larger, and staying a longer period of time, than originally planned. While visitors enjoyed the BioLounge, staff members responsible for changing exhibits were becoming fatigued. The routine of nearly constant change was difficult to handle; it was too different from the "design-build-open and on to the next hall" routine well-known in the museum world.

Within the last year, the museum has employed ambassadors in the Bio-Lounge. The ambassadors are CU students working for the museum who create dialogue with visitors in order to gather information as to how the museum could better serve the target audience. Assessment instruments were developed to ascertain awareness of issues raised in the exhibitions as well as inquiring into the types of products that might be purchased by the CU-student audience in our museum gift shop. The museum used this feedback to dramatically increase sales in the store, with a one-year increase in overall sales and net revenue of 20 percent and 94 percent, respectively. This performance is certainly due to the conversations we have had with visitors to the BioLounge, especially our CU students.

LESSONS LEARNED

Design Matters.

One of the consistent messages we have received about the BioLounge from visitors (from other museums as well as our CU students) is that

the space does not look like a typical museum gallery. This is intentional, from the furniture, to its arrangement, to the choice of colors, to how those colors are used. We are aiming to make the space feel welcoming by design (making the museum "convivial," as noted by McLean and Pollock 2011).

Stay the Course.

At many points along this road, concerns were raised by museum faculty and staff about the original concept. We had no early designs, and the pace of implementation was quick. Staying the course by being true to the original implementation and focusing efforts on the target audience has been, and continues to be, a significant challenge for the entire museum.

Is It Only about Free Coffee?

As this program unfolded, we received significant resistance from museum peers who cited the success of BioLounge as being due to one thing: free coffee! Feedback from visitors as to why they visit the BioLounge recognizes the free coffee and tea, but usually speaks to the setting, interesting exhibitions, and welcoming environment. Free food was offered by the museum in the past, and student reaction to that offer was modest at best.

Change Is Hard.

The BioLounge has turned out to be more than installing and maintaining a new exhibition in a gallery where there was a pressing need to update an outdated exhibition. It really has been a place to take on interesting topics, explore ways to engage and learn from visitors, and encourage visitors to use the space. But BioLounge has also been internally focused in terms of how exhibitions are developed and carried out. This was especially evident in the conflict between the desire for frequent, predictable change and prevailing staff culture. Changing staff culture is very hard.

Is It for Everybody? Feedback from Other Museums.

The outcomes of the BioLounge, especially the increases in audience from a segment usually characterized as difficult to attract, have intrigued professional audiences with whom it has been shared, including Colorado-Wyoming Association of Museums, Mountain-Plains Museum Association, and American Alliance of Museums. Intrigue with the concept, delivery, and outcomes has usually given way to skepticism from many

museums, large and small, who suggest it is not a program that is right for them. Some have worried about how to admit frequent visitors to their spaces when there is an entrance fee, and others have voiced concerns that it is not really a true museum experience. Some worry that having coffee and tea in the gallery will lead to increased numbers of pests. This is something we monitor diligently, and we have no data to support that concern. The BioLounge has reinvigorated the Museum of Natural History at the University of Colorado, Boulder. Programs like the BioLounge might be an option for museums focused on serving and engaging campus students, faculty, and staff.

ACKNOWLEDGMENTS

I want to express my appreciation to the many museum staff for their dedication and hard work on the BioLounge. Special thanks to Susan Reinke and Samantha Eads for data summaries, and Sharon Tinianow for her helpful edits to the manuscript.

RESOURCES

Brunecky, J. "An Analysis of Institutional Support for Young Adult Programming: How Six Denver-Metro Area Cultural Institutions are Adjusting to Changing Patterns of Cultural Participation among a Young Adult Audience." Master's Thesis, University of Colorado, Boulder, 2010.

Glesne, C. *The Campus Art Museum: A Qualitatative Study. IV. Challenges and Conditions of Success for Campus Art Museums.* A Report to the Samuel H. Kress Foundation.

Krishtalka, L. and Humphrey, P. S. "Can Natural History Museums Capture the Future?" *Bioscience* 50: 2000, 611–17.

Mauries, P. *Cabinets of Curiosities.* New York: Thames & Hudson, 2011.

McLean, K. and Pollock, W. *The Convivial Museum.* Washington, DC: Association of Science-Technology Centers, 2011.

Shapiro, T., Linett, P., Farrell, B. and Anderson, W. *Campus Art Museums in the 21st Century. A Conversation.* Chicago: Cultural Policy Center, University of Chicago, 2012.

Silver, A. Are Our Lives Vanishing into the Cloud? *The Atlantic.* May 20, 2011. www.theatlantic.com/technology/archive/2011/05/are-our-lives-vanishing-into-the-cloud/239206/.

TEN

Art and Beer: The Drunken Cobbler

Sarah Lampen, Stephanie Parrish, and Eric Steen, Portland Art Museum

Stop thinking about art works as objects, and start thinking about them as triggers for experiences.

—Brian Eno

Founded in 1893, the Portland Art Museum in Portland, Oregon, is the seventh oldest art museum in the United States with over forty thousand objects in its collections. As it moves toward its 125th anniversary, the Portland Art Museum remains one of the anchor cultural institutions in a region that has recently become nationally known for its locavore food and hipster youth cultures more so than its once-dominant timber and shipping industries. Today, Portland looks very different than it did even twenty-five years ago, much less its late nineteenth-century self.[1]

As the city has shifted, so too has the Portland Art Museum, although at what close observers might say is a slower pace. In 2010, a new five-year institutional strategic plan was developed with input from a wide range of museum staff and community members. Six key strategic directions emerged, including "Innovate to create compelling audience experiences." This particular strategic direction spoke to new and more participatory forms of exhibition and public programming that started to emerge at the museum in 2008 and were on the rise at other art museums around the United States at the time.

Often referred to internally as "experimental," the institution began a process of rethinking museum experiences and how they might be relevant to the under-thirty-five crowd migrating in ever larger numbers to the city. With this in mind, exhibitions and programs included small permanent collection shows like *Marking Portland: The Art of Tattoo* (2009) that explored tattoo and body adornment across time and place and

included two related interactive projects. Through successful "experiments" such as these and others, the museum was increasingly listening to and in conversation with vital and creative voices in the Portland community who had not necessarily thought about the art museum as a place for them, and also may not have considered its collections as personally meaningful. Internally and externally there was a feeling that the museum was becoming not just a museum *in* Portland but a museum *of* Portland.

The year 2009 also marked the first year of a new partnership between the museum's education department and the relatively new MFA program in art and social practice at Portland State University. Through a series of conversations and internal museum negotiations, education staff worked with over a dozen social practice students to develop a single night of multiple artist interventions inside the museum's galleries. The night became known as *Shine a Light* with the secondary title *Rethink What Can Happen in a Museum*. Although wildly successful with visitors, *Shine a Light* presented internal challenges over its now five-year run, limiting how deeply it could collaborate with a particular artist.

PLANNING

In 2013–2014, the museum began to recalibrate *Shine a Light* with an eye toward extending socially engaged and experiential work beyond a single night. Among the first artists to work with the museum in a closer way, and over an extended nine-month period, Eric Steen began a new iteration of his *Art and Beer* project that initially took place at *Shine a Light* in 2009 and 2010. It was fall 2013 when the three authors of this chapter came together to talk about a new direction for *Art and Beer*, a direction that would explore not only the physical, scientific, and art historical layers of a single work of art, but also the emotional and subjective layers that come with personal acts of interpretation. Steen proposed a project that involved searching for and cultivating a fermentable yeast directly from an object in the collection that could be shared with multiple brewers who would then create their own beer interpretations based on the yeast strain. In other words, was it possible to literally brew beer from a painting? For the project, Steen and museum staff agreed that Jean-Baptiste Greuze's genre painting, *The Drunken Cobbler*, c. 1780–1785, would offer the perfect opportunity for this project, as it is one of the museum's most noted art works but is little known to today's museumgoers. What follows is a summary of *Art and Beer: The Drunken Cobbler*, 2014.

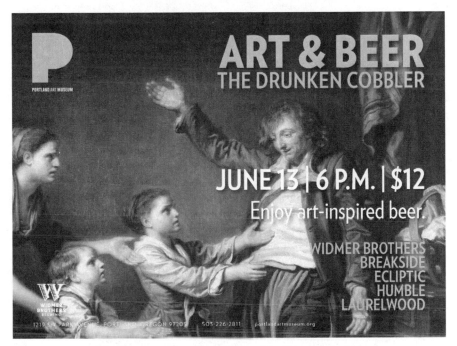

Figure 10.1. Marketing poster for *Art and Beer: The Drunken Cobbler*.

IMPLEMENTATION

The first steps Steen and museum staff took were to explore the process of harvesting yeast from a painting without physically harming it and to determine the final scale and scope of the project. Steen decided to invite between three and five local brewers to make beer fermented with yeast collected from *The Drunken Cobbler*. The beer would debut at the museum at a special event during Portland Beer Week, in six months' time. The event would host over two hundred people and would take the form of a beer tasting and a moderated panel discussion. In it, Steen would address the project's trajectory, the museum's curator would discuss the selected painting in light of provenance and historical relevance, each brewer would briefly talk about his beer, and the museum's conservator would explore the painting's condition and care.

In February 2014, Parrish and Lampen arranged to have *The Drunken Cobbler* removed from the gallery for the purpose of harvesting yeast. The museum's conservator, Elizabeth Chambers, and Leon Fyfe, the microbiologist from Widmer Brothers Brewing, determined that swabbing the

canvas with sterile cotton swabs and distilled water would be the safest collection method. Chambers supervised as Fyfe swabbed the border, frame, and back of the painting. The samples were returned to the lab at Widmer Brothers Brewing and placed in a petri dish for growth. After two weeks a fermentable strain did not materialize. After further trial and error, Steen realized that it might not be possible to obtain a fermentable yeast. Steen then decided to ask the brewers to create beer inspired by the artwork without using yeast collected from the museum. Steen eventually confirmed a total of five local breweries to take part in the project: Breakside Brewery, Ecliptic Brewing, Humble Brewing, Laurelwood Brewery, and lead partner Widmer Brothers Brewing. Each brewer visited the painting in the museum with Lampen, who shared her knowledge of the artist and work, answered their questions, and made suggestions for research. The brewers then got to work brainstorming and brewing beers inspired by what they had observed and learned.

In the meantime, Steen worked with museum staff to finalize plans for the design, structure, and marketing of the public tasting event scheduled for June 13, 2014. In order to expand its reach, museum marketing focused on the beer community, which was an integral part of the project's success. The museum paid to advertise the event through Portland Beer Week and other targeted marketing. Steen coordinated coverage by local news outlets, and the museum promoted the event through social media to reach as broad an audience as possible. The event eventually sold out in advance at 330 tickets, the vast majority of which sold to individuals who were not museum members, helping to realize an institutional goal of welcoming new and diverse audiences.

At the event itself, all voices came together to collectively share the project's development and journey. From the institutional side, curator Dawson Carr spoke about the artist, the historic context of *The Drunken Cobbler*, and possible interpretations of the scene. Elizabeth Chambers, the museum's conservator, spoke about the process of cleaning artworks, what measures the museum takes to maintain a safe atmosphere for artworks, and the conservation record of the painting. While beer was poured and served, each brewer explained what ingredients, flavors, and brewing techniques inspired their individual recipes. Carr's and Chambers's presentations added another dimension to the brewers' interpretations and highlighted the similarities between their respective practices. The event ended with an audience question and answer session, and visitors were encouraged to visit the *The Drunken Cobbler* in the museum galleries, which were kept open late.

Afterward, reviews of the event on beer blogs confirmed that those in attendance found the event to be innovative, informative, and even a bit magical. Essentially, the event welcomed new groups of people to the

museum to explore a single image through multiple lenses. The present-ers who were experts in various fields expanded their interpretations and their relationships to the work of art and demonstrated for the audience "the ability of objects to act as triggers for experiences" when accessed through individuals' own life experiences.

RESULTS

Portland currently holds the record for more breweries than any other city in the country, so partnering with five local breweries was a perfect way to create innovative, place-based programming. A defining aspect of this program was that it came to fruition primarily through a true collabora-tion between artist Eric Steen, the Portland Art Museum, and Widmer Brothers Brewing. The Portland Art Museum was extremely pleased with *Art and Beer*, as it supported several strategic goals related to developing innovative forms of audience engagement—the inception of sustainable partnerships with artists and community groups within Portland, the creation of programs that welcome new and underserved demographics, and increased cross-departmental collaboration.

Without a structured form of assessment, it is hard to gauge the im-mediate impact and long-term implications of the event on the Portland community. Much like our peer institutions, the staff at the Portland Art Museum grapples with the lack of resources to effectively measure the efficacy of the work we do, and we thus must rely on anecdotal evidence, which has been overwhelmingly positive.

Also, like many museums, the Portland Art Museum has trouble at-tracting visitors aged eighteen to thirty-five, so the high attendance rate among millennials and their engagement with the museum via social me-dia as a result of this event was encouraging. The audience's enthusiasm translated into *The Drunken Cobbler* becoming the most-viewed artwork in Online Collections, one of the Portland Art Museum's digital resources. As *Art and Beer*'s marketing presence grew, so too did hits on *The Drunken Cobbler*, spiking on June 13, 2014, the day of the *Art and Beer* event. What is particularly exciting is that 40 percent of visitors remained in Online Col-lections to view other artworks, helping the museum to achieve its goal of building awareness of Online Collections as a resource.

Perhaps the most sustained gratifying impact of the project has been on the staff of the Portland Art Museum. The project forced all involved to think creatively, flexibly, and most importantly—collaboratively. Many mu-seum professionals experience the common gulf between the priorities of education and curatorial departments. *Art and Beer* encouraged colleagues to identify and validate the commonalities between their practices.

Art and Beer is a project that is scalable and replicable, primarily because it promotes the collaborative internal culture necessary to create truly thoughtful and site-specific, artist-driven programming. Everyone on the final planning team relinquished their position of authority in relation to the interpretation of artworks and made room for the brewers' interpretations and a reimagining of the forms that interpretation can take.

LESSONS LEARNED

Though the museum was extremely pleased with the outcomes of *Art and Beer,* there are several things that could be improved in the next phase of the project. With the incredible richness of the brewing community in Portland, the project easily grew to include five breweries, which meant that the coordination involved in the project was immense and difficult to manage given the limited museum staff and budget. Artist Eric Steen helped to ensure that the project remained true to his initial vision, while being understanding of the constraints and limitations of the museum and breweries' brands and staff.

Our advice to other museum professionals interested in producing similar programming would be to first and foremost—get to know your city. While a project like this would be successful in many cities, it's important to familiarize yourself with your community and its particular needs and interests, and program accordingly.

Additionally, targeted marketing is one of the largest factors that determine the success of a project, because programming doesn't exist without an audience. We made sure to plan our event to coincide with Portland Beer Week, and Steen worked tirelessly to secure coverage in beer periodicals, blogs, and schedules. Without this publicity, and our collaboration with the five breweries, we wouldn't have been able to reach individuals and new demographics outside of the museum's network.

Finally, whether approaching museum visitors or colleagues, it is important to meet people where they are in order to have a truly collaborative experience. Universal buy-in is vital to the success of an initiative, which means relinquishing some control in order to facilitate a community of co-creators. We have found that the most important skill to hone when collaborating with artists and community partners is the ability to "let go."

DRILLING DOWN: WHAT'S NEXT?

Let's return to the words of musician, composer, and visual artist Brian Eno, who opened our chapter. When Eno urges, "Stop thinking about art

works as objects, and start thinking about them as triggers for experiences," would he imagine a project like *Art and Beer: The Drunken Cobbler*? We all think the answer is a resounding yes. The Portland Art Museum's permanent collection is a platform that can and should be cracked open for new forms of dynamic interpretation. While Steen and the museum are already discussing what *Art and Beer* 2015 will look like, one of the biggest lessons from this ongoing project is the reminder of the necessity that we continue to push for the creation of interpretative moments that merge the museum's community with its collection. Cheers!

NOTE

1. See the 2012 study conducted by Portland State University, www.citylab.com/work/2012/09/portland-really-where-young-people-go-retire/3316/, accessed September 20, 2014.

RESOURCES

Brewpublic.com. "Beer Inspired by Art at the Portland Art Museum." brewpublic.com/beer-events/beer-inspired-by-art-at-the-portland-art-museum/.

Nelson, Erik. "Guest Blog: Art and Beer: The Drunken Cobbler." Brewvana: Portland Brewery Tours. www.experiencebrewvana.com/2014/06/guest-drunken-cobbler/.

Portland Art Museum. "Art and Beer: The Drunken Cobbler (2014)." www.portlandartmuseum.org/artbeervideo.

Steen, Eric. www.ericmsteen.com/p/portfolio.html.

Index

About the Contributors

Charles Chen is an exhibit developer/experiential technologist at the Smithsonian National Museum of Natural History. His interests lie in realizing the potential that museums hold in affecting constructive social change, as well as innovating with interactive technologies to engage audiences.

Anne Corso is currently the director of education at the Chrysler Museum of Art. She has previously served as director of education at the Delaware Art Museum in Wilmington and the Reading Public Museum in Pennsylvania.

Juilee Decker is an associate professor of museum studies at Rochester Institute of Technology (RIT). She earned her Ph.D. from Case Western Reserve University. Decker's research interests and curation include public art, commemoration, and memory as well as the social application of museum informatics. Since 2008, she has served as editor of *Collections: A Journal for Museum and Archives Professionals*, a peer-reviewed journal published by Rowman & Littlefield.

Jan Freedman is curator of natural history at Plymouth City Museum and Art Gallery. He looks after the geology, botany, and zoology collections, which hold some incredible specimens. His two main areas of specialisms are Quaternary fossils and science communication.

William Hennessey has served as the director of the University of Michigan Art Museum, University of Kentucky Art Museum, and the Vassar College Art Gallery. In 2014, he retired as the director of the Chrysler Museum of Art after seventeen years, during which he transformed the

institution into one of the nation's best midsize art museums and a model for customer service.

Ashley Hosler is the senior education coordinator of family programs at the Walters Art Museum. With her B.F.A. in painting and her M.A. in teaching, she has served children and families in a wide variety of educational capacities since 2007. From working intimately with school systems, private and nonprofit organizations, and ultimately cultural institutions, Hosler has designed and implemented a diverse range of arts-based curricula for all audiences. With a vested interest in art education as an opportunity for therapy, communication, and socialization, she continues to employ access-driven experiences to engage young visitors of the museum.

J. Patrick Kociolek is the director of the Museum of Natural History and professor of ecology and evolutionary biology at the University of Colorado, Boulder. He was previously the executive director of the California Academy of Sciences in San Francisco.

Sarah Lampen is the coordinator of docent and tour programs at the Portland Art Museum and has an M.A. in art history from the Institute of Fine Arts, New York University, as well as a B.A. in art history with a minor in educational studies from Carleton College. She has five years of museum education experience and has worked with school and tour programs, docent programs, teacher resources, teen programs, accessibility programs, adult public programs, and interpretation at seven art museums across the country. These diverse experiences inform her work at the Portland Art Museum.

Jennifer L. Lindsay is an independent consultant and curator. Since 2010, she has worked with museums, arts organizations, civic organizations, and businesses to develop creative, site-specific exhibitions, projects, and public programs that merge art, science, and community engagement.

Margot Note is the director of archives and information management at World Monuments Fund, an international historic preservation organization. In addition to providing vision and leadership for the information needs of the organization, she initiated and manages WMF's Instagram account and provides strategy for maximum social media engagement.

Stephanie Parrish is the associate director of education and public programs at the Portland Art Museum (Oregon), where she oversees public engagement programs of all kinds, including artist residency and par-

ticipatory programs. She has held education and/or curatorial positions at the Kemper Art Museum (Washington University in Saint Louis), the Saint Louis Art Museum, and the National Museum of American Art/National Portrait Gallery (Smithsonian Institution) and earned a B.A. from New York University and an M.A. from Washington University in Saint Louis—both in art history.

Marisa J. Pascucci is an experienced curator, author, speaker, and educator. She holds a senior leadership role at the Boca Raton Museum of Art as curator of collections. Previously she was associate editor of *The Art Economist*; adjunct faculty member at Palm Beach State College; curator of American art at the Norton Museum of Art; senior curator at the Everson Museum of Art; and associate curator at the Montgomery Museum of Fine Arts.

Janet Sinclair is curator at Stansted Park, an Edwardian country house. She also works as an independent lecturer in the history of art and historic interiors and consultant curator. She holds a B.A. (honors) from the Courtauld Institute of Art, the PGCE (postgraduate certificate in education) Leeds, and an M. Phil. from the Barber Institute, Birmingham.

Siobhan Starrs has been an exhibition developer/project manager at the Smithsonian's National Museum of Natural History for over fourteen years. She is currently the project manager on the renovation and exhibition redesign on the museum's National Fossil Hall—the largest renovation of public space in the museum's history.

Barbara W. Stauffer works at the Smithsonian's National Museum of Natural History, where she develops public programs that engage new and diverse audiences with the museum's mission and creates outreach projects that link people to the museum's collections, exhibitions, and research.

Eric Steen is an artist, award-winning art teacher, and the founder of Beers Made by Walking. His work has been exhibited at Performa and Food Book Fair (New York City); Glasgow International Festival of Visual Art (Scotland); Urban Culture Project (Missouri); Design Week Portland, Portland Art Museum (Oregon); and has been created independently with breweries and environmental organizations around the country.

Alison Zeidman is the social media and communications specialist for the Greater Philadelphia Cultural Alliance. Previously, she worked as the alliance's policy and community engagement manager and worked to launch and manage the STAMP teen program in its inaugural year.